cubic feet /sec.

The rate at which flowing water is measured in a river.

The Grand Canyon. 1979-2013

Since the summer of 1979, when my father and I first journeyed down the Colorado River through the Grand Canyon, we have tried to tell the story of adventure through photography. At first, as an 11 year old, my camera was a Kodak Instamatic 110. Four rolls of film accompanied me, each roll and each frame carefully rationed and considered, the resulting stack of small square prints from the drugstore were a disappointment, a far cry from my memories of the canyon.

As luck would have it, the Grand Canyon, and photography would become major parts of my life. Obsessed with rivers and rafting the Colorado River, my father and I, and many good friends, would travel the river through the Grand Canyon 9 times together in 34 years. On each trip, with coolers filled with film, cameras would become a fixed element on every journey. My interests in photography sprouted at this time, in the mid 80's when it seemed a worthy cause to show "the folks back home" the magic of the canyon.

For the next 4 decades, thousands of Kodachrome slides filled tray after tray as we carefully edited slideshows to show to sometimes rather large audiences. We thought we were sharing the experience. Though I'm sure most people who saw our shows went away with a thrill, I could never help feeling that photography was never going to do what I wanted it to do. This failure, of course, is not photography's, but mine - my lack of understanding what it can never do. Still, I carried cameras along, each trip being a new chance to get it right.

The cameras changed over the years, covering the entire spectrum of photography; my Kodak Instamatic, an Argus C3, various 35mm SLRs, Hasselblads, Nikonos diving cameras, Yashica twin-lens, a range of digital disappointments, 4x5 field cameras and an HD helmet camera. None of the cameras proved worthy of the task, each failed, I failed.

Only recently, when I took on the task of sorting through the thousands of images and seeing them as a whole - a complete journey and not fragments of past decades - did I see the memories and adventures flow into one story, one trip. As I watched us get older, the canyon stayed, more or less, the same. Suddenly it made sense, this new edit where time is thrown out the window and the canyon is the only constant. This, finally, is the slideshow we could never make.

The first picture is possibly the first photograph I ever made. It is a few miles downstream from the put-in at Lee's Ferry, 1979. It was my first camera, our first trip, the first day. When I look at it now in the context of my work over the last 20 years, the work I have spent my adult life considering and troubling over, I have to admit whether good or bad, irrelevant or disastrous - that it fails no more, or less, than any I've taken since.

A.P. 2015

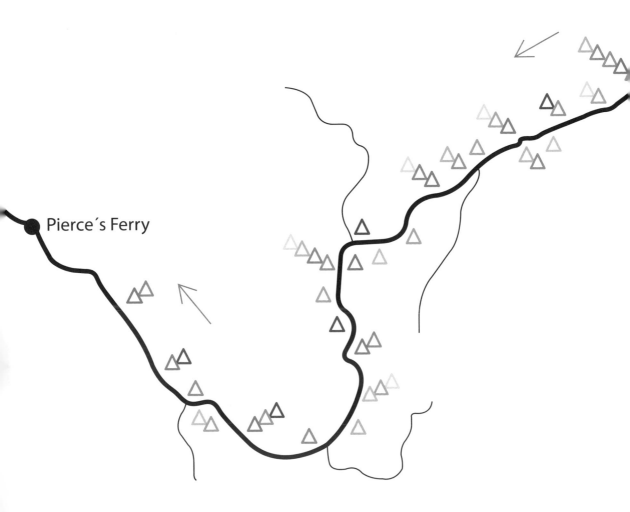

ARIZONA

Pierce´s Ferry

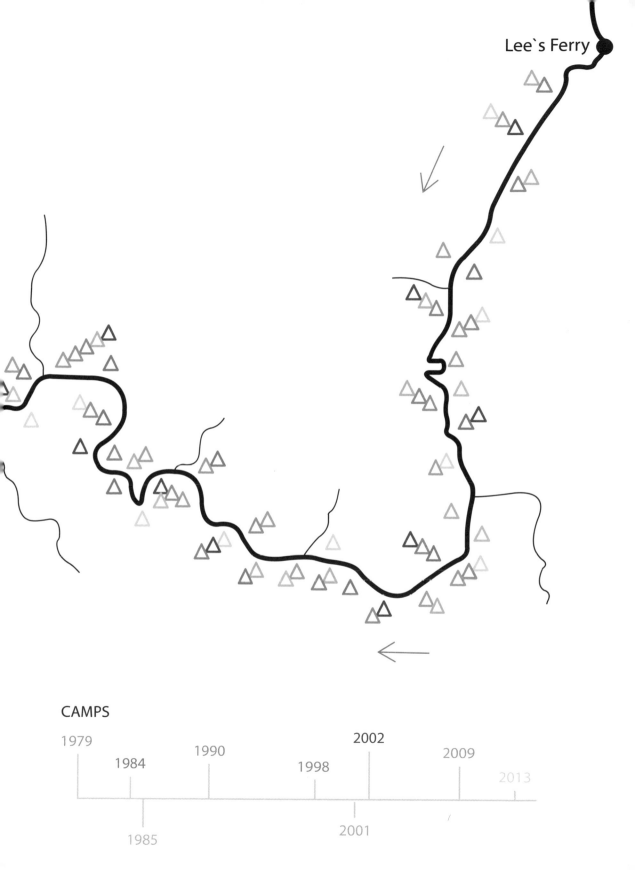

Lee`s Ferry

CAMPS

1979
1984
1985
1990
1998
2001
2002
2009
2013

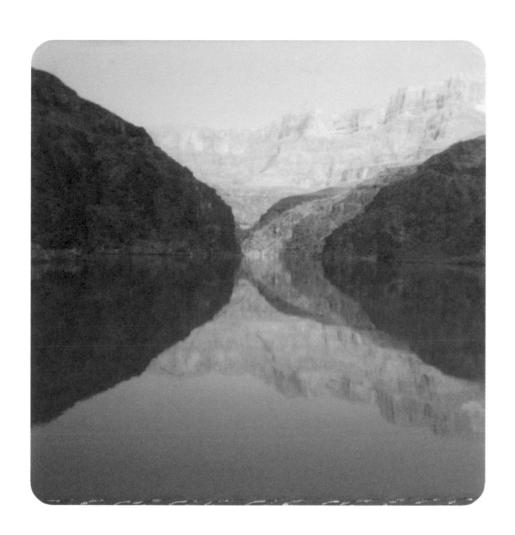

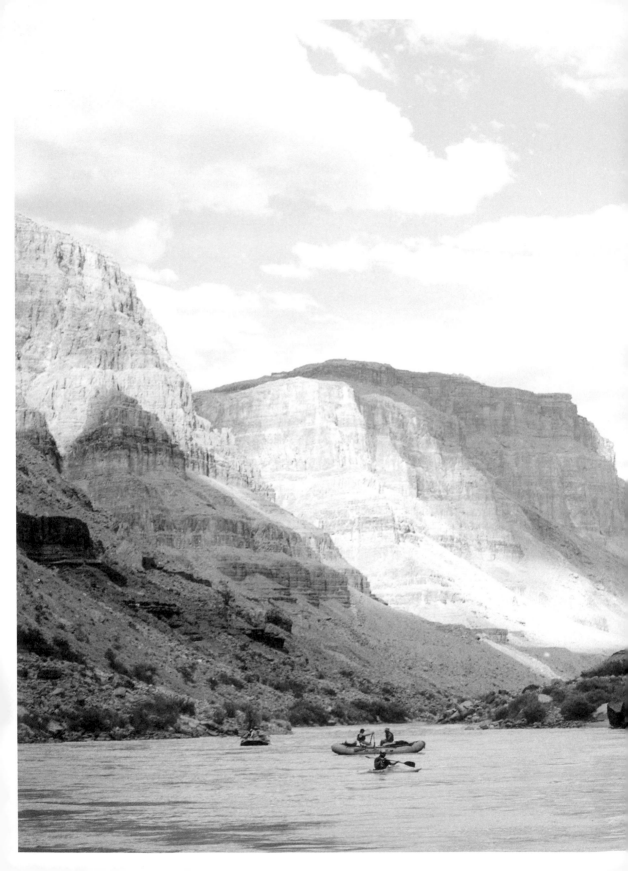

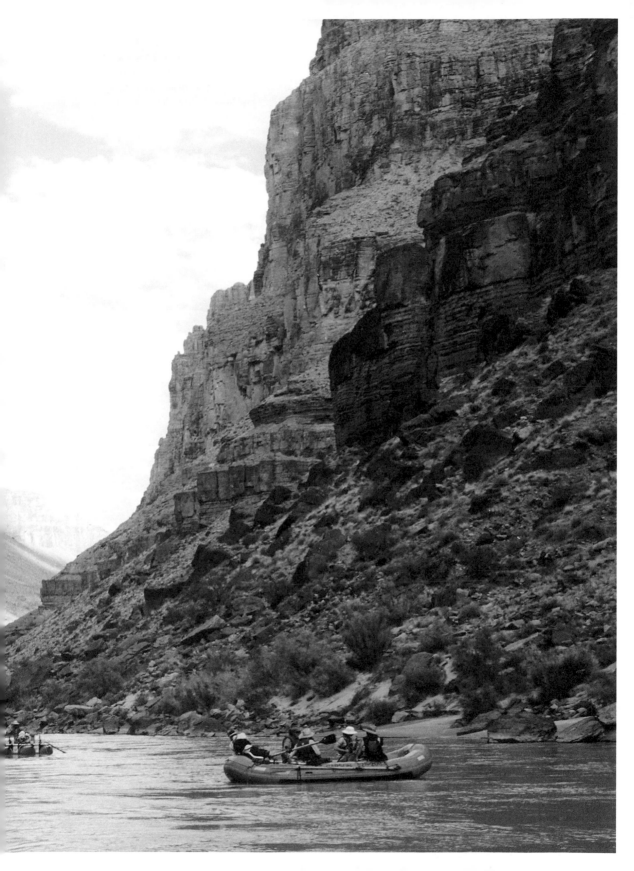

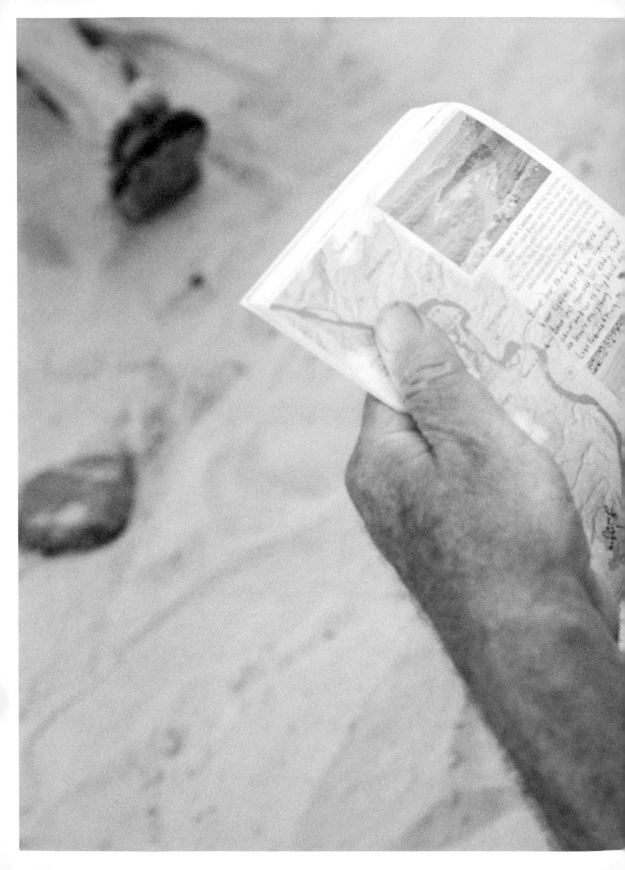

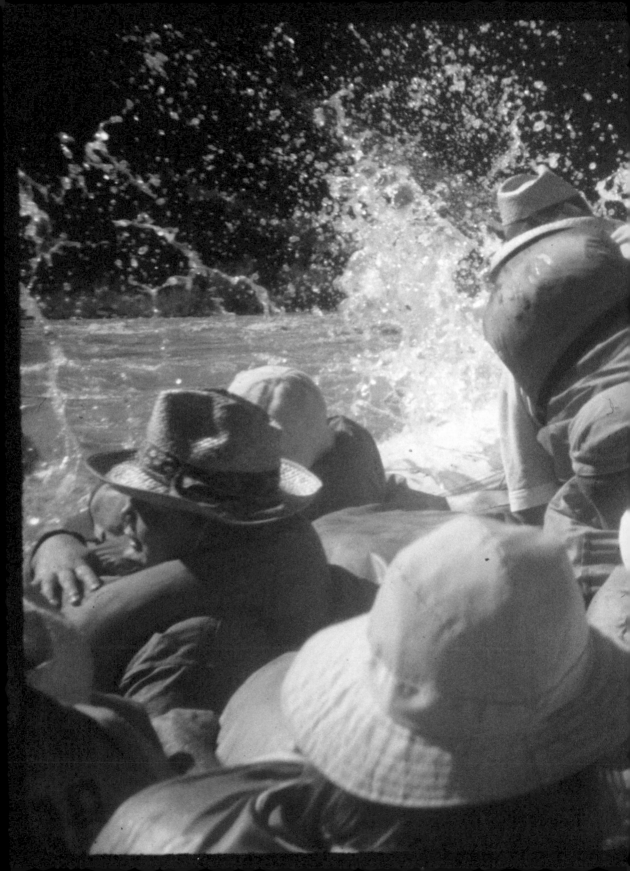

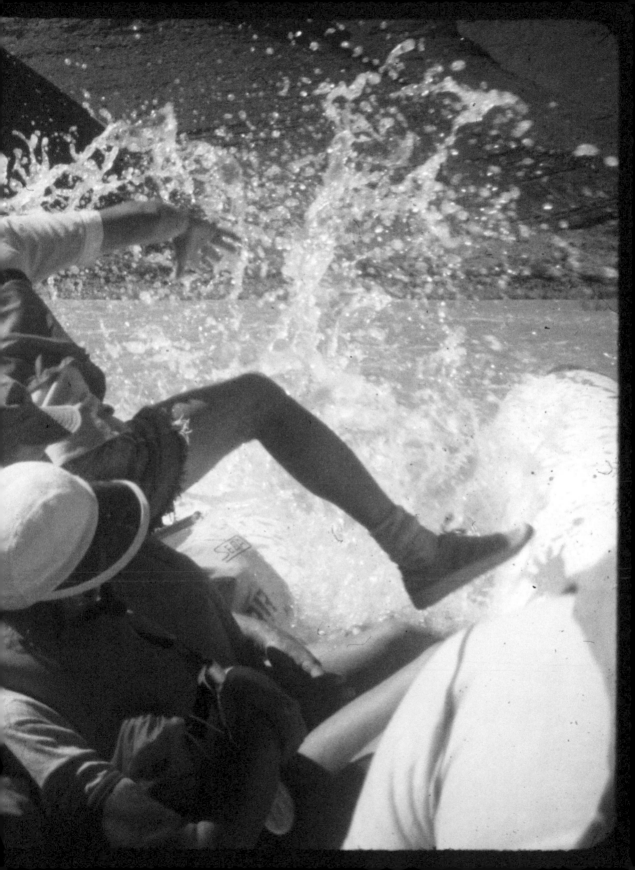

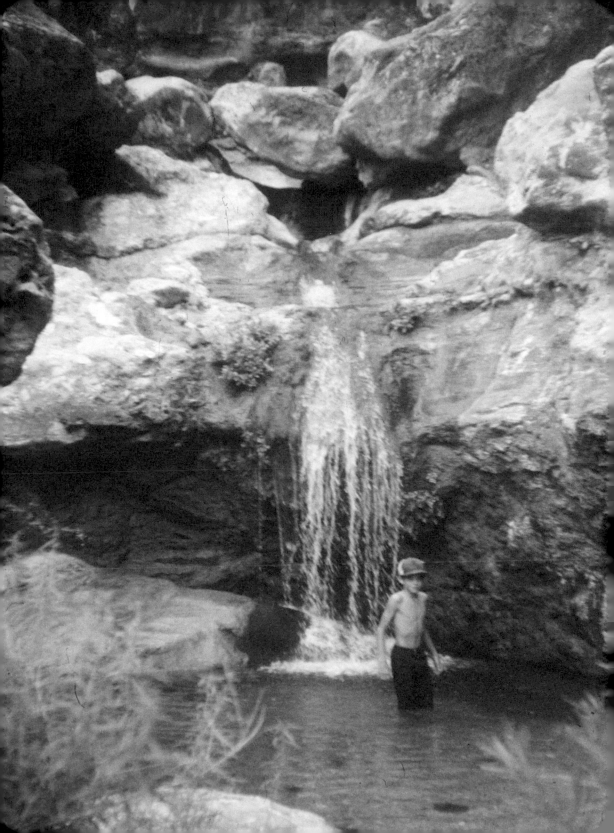

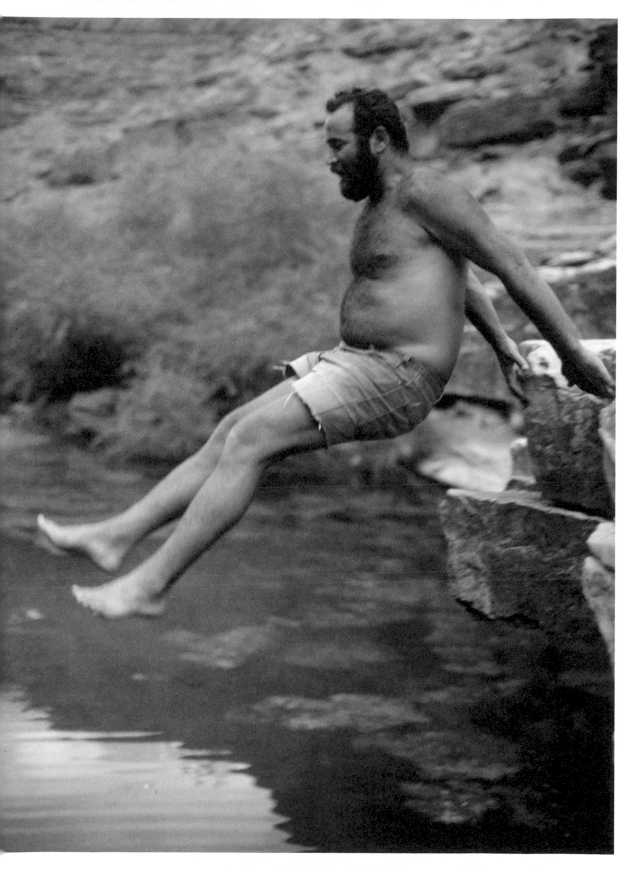

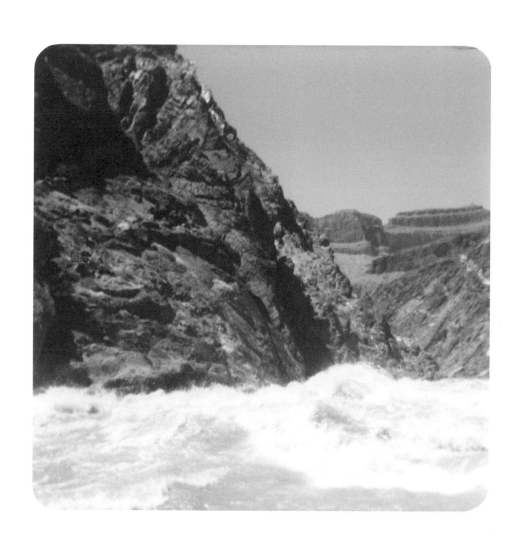

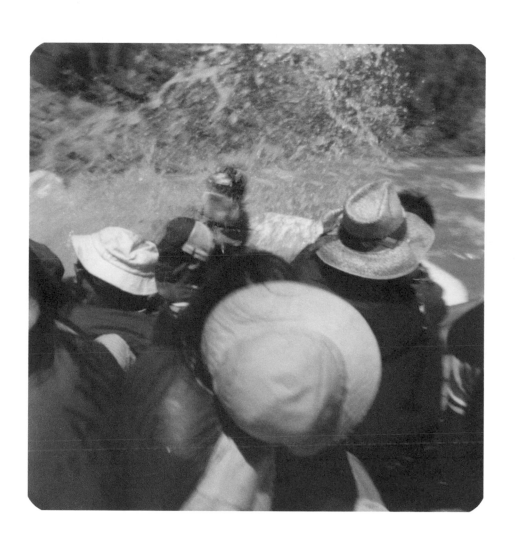

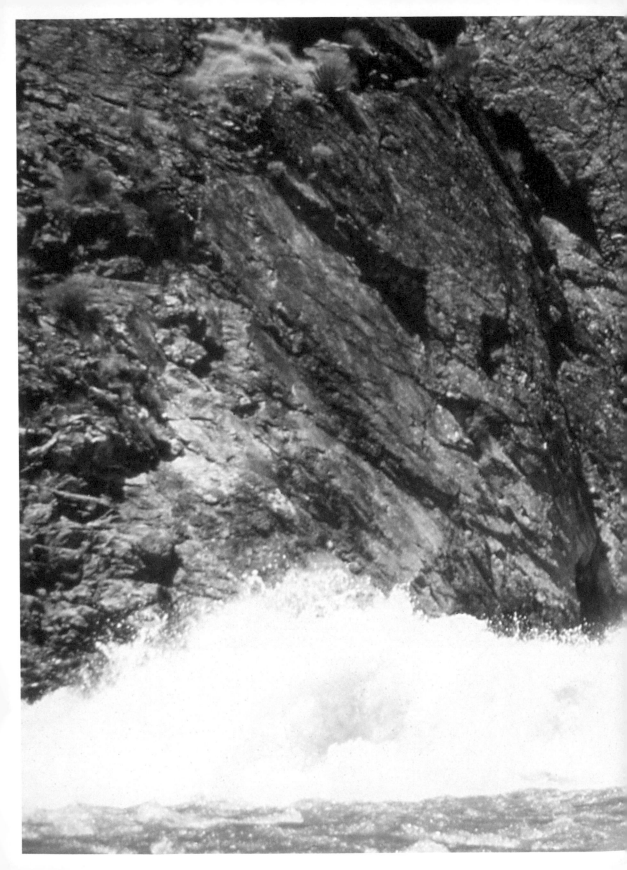

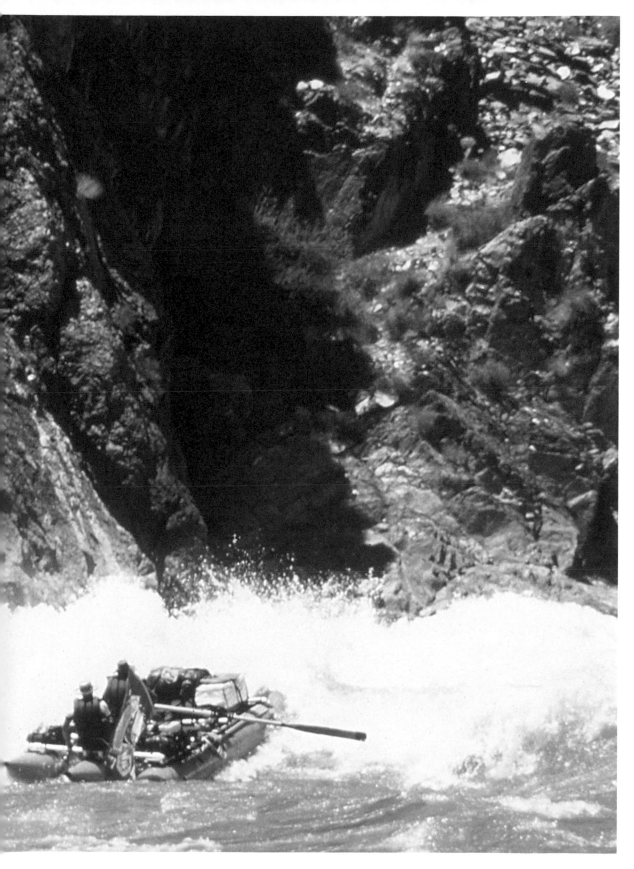

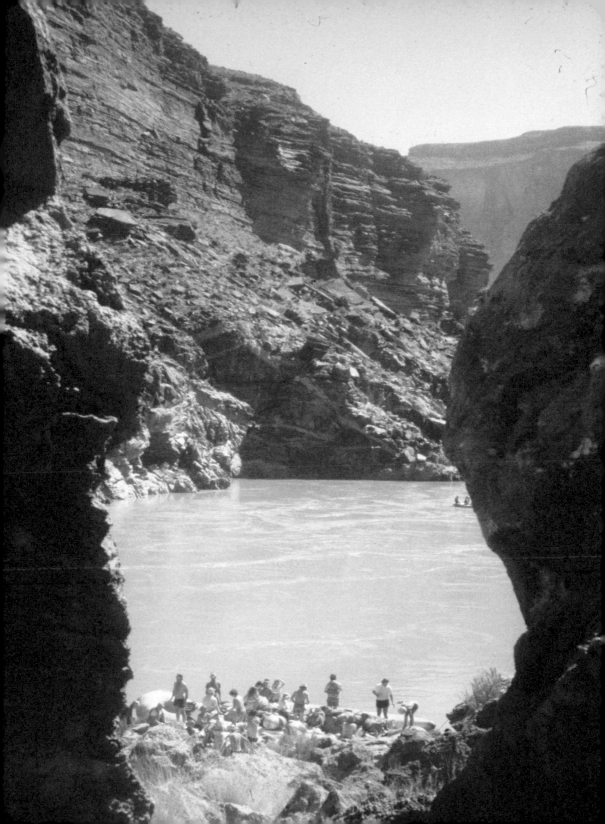

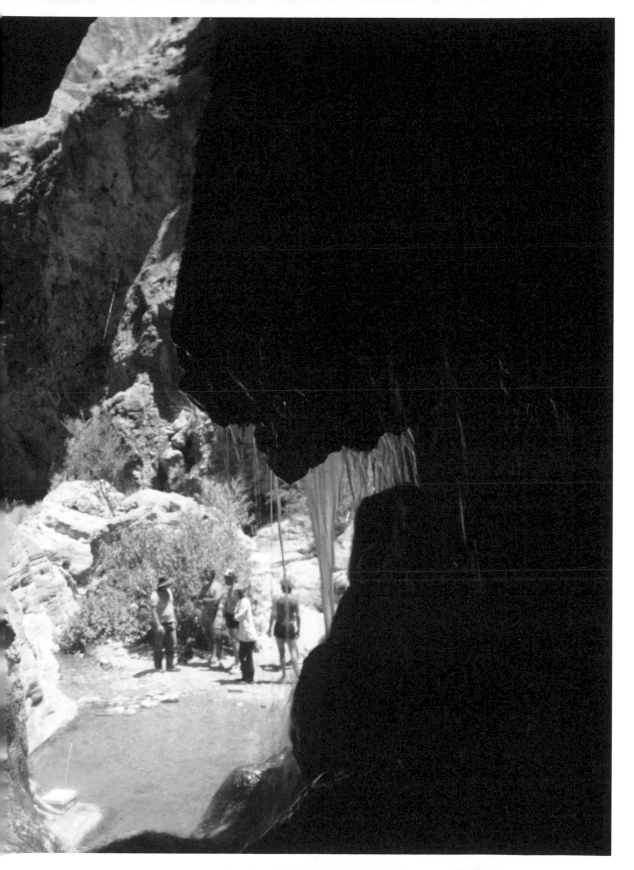

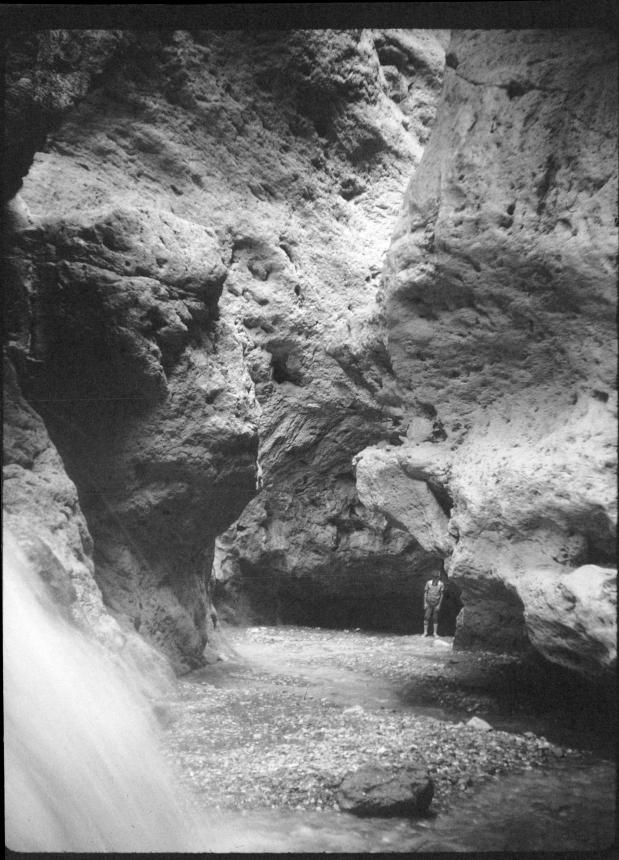

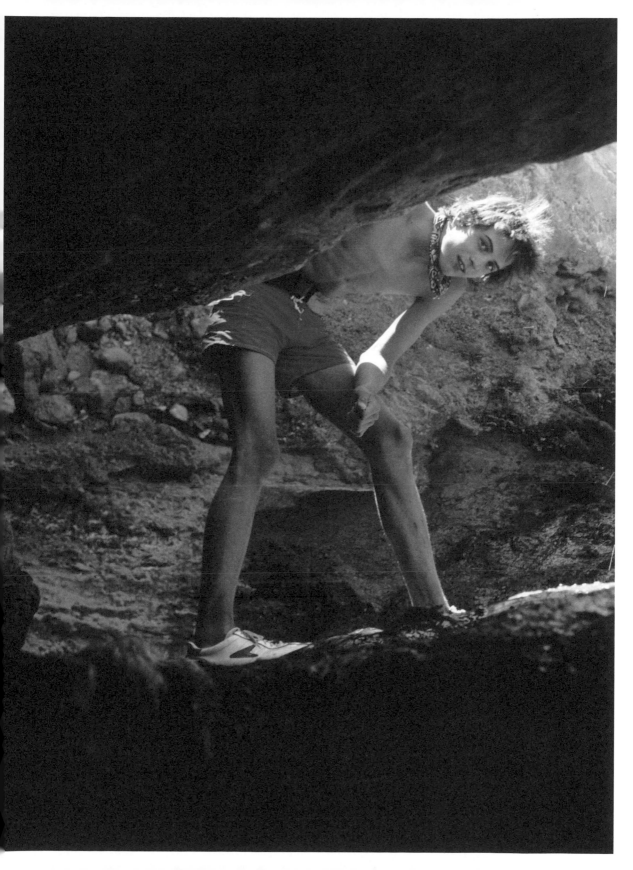

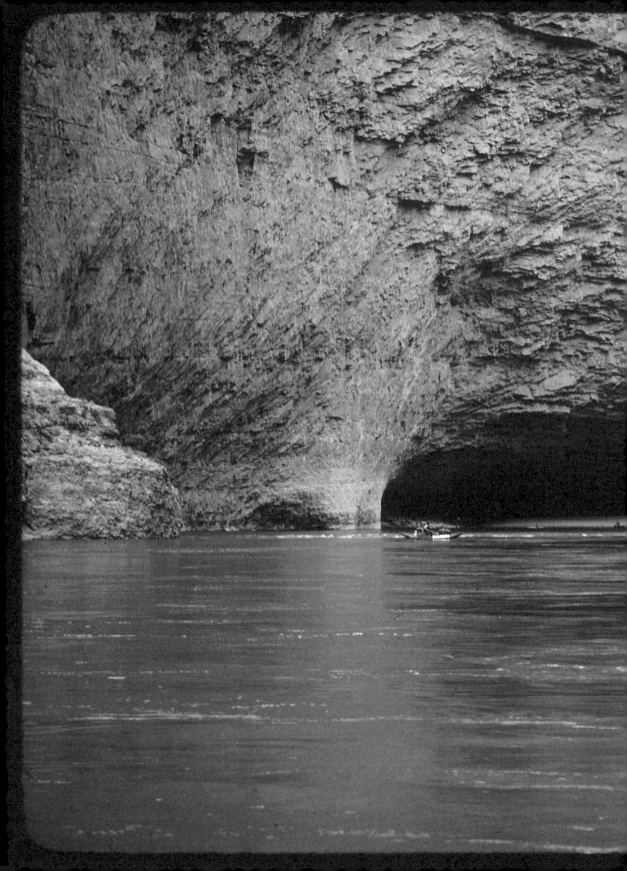

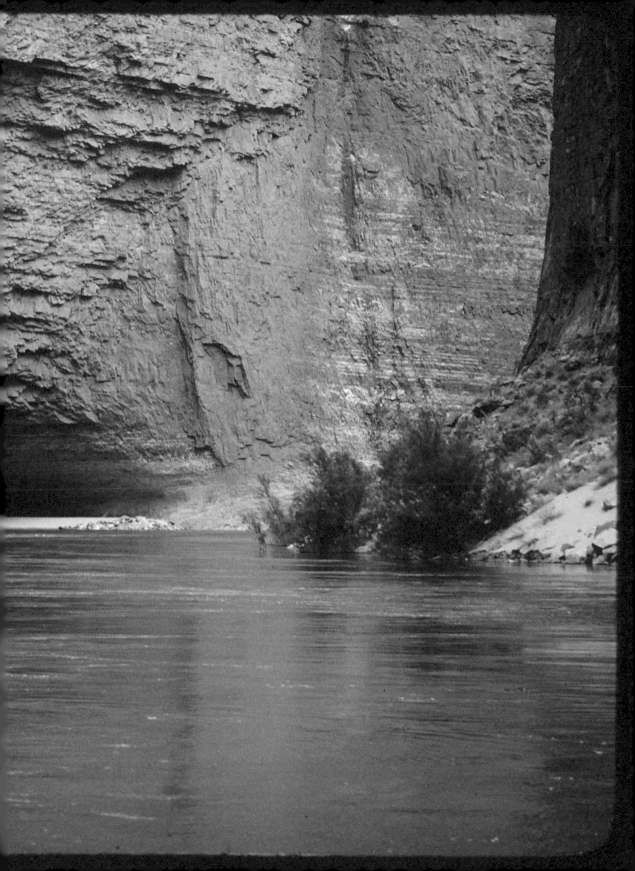

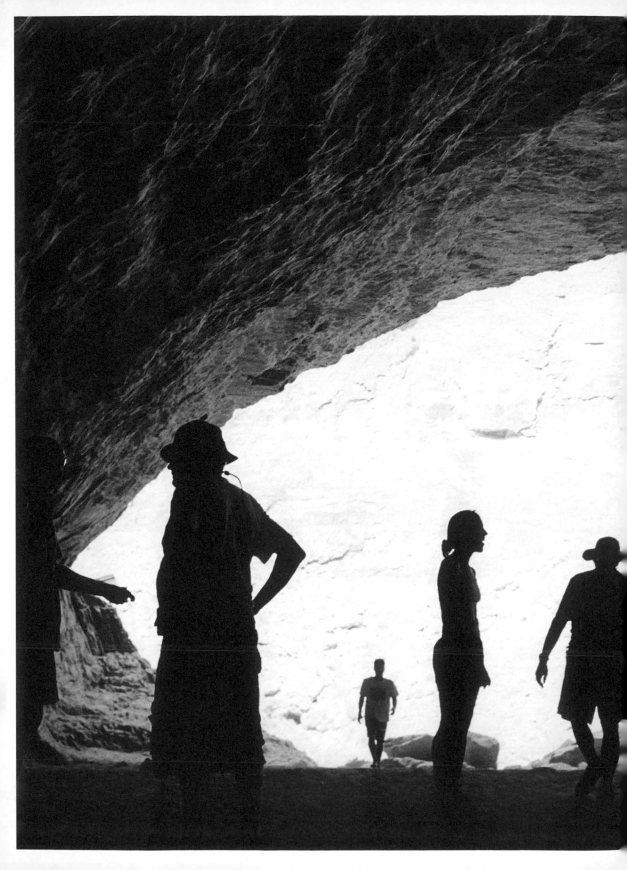

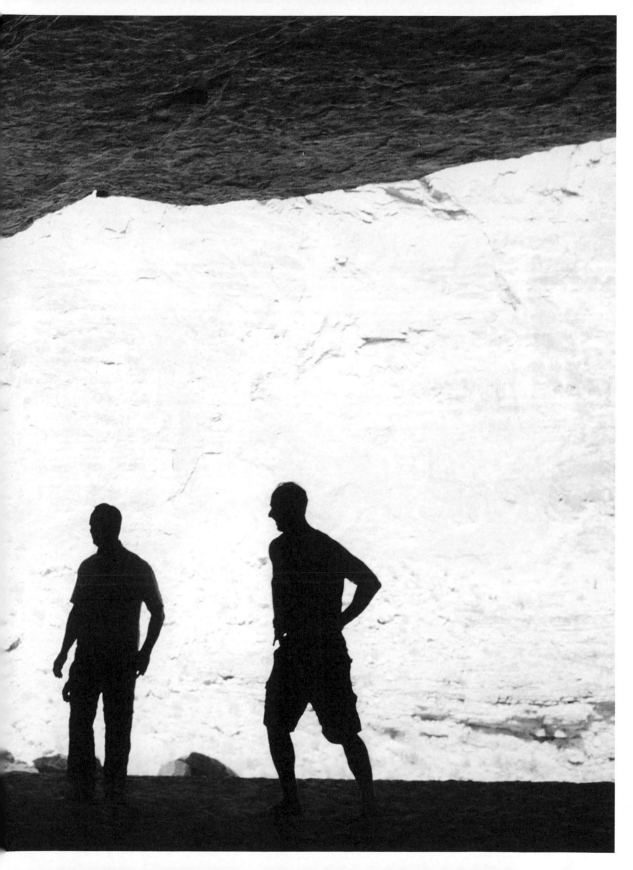

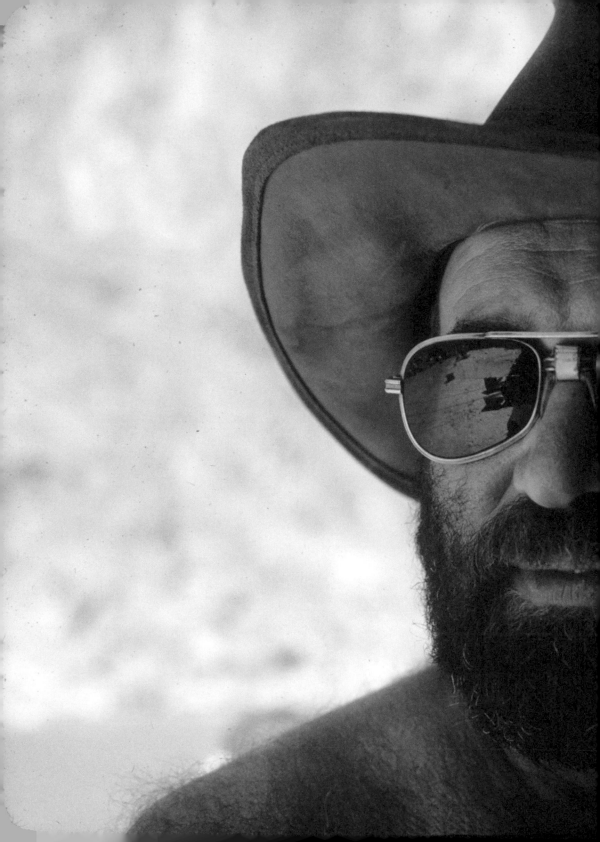

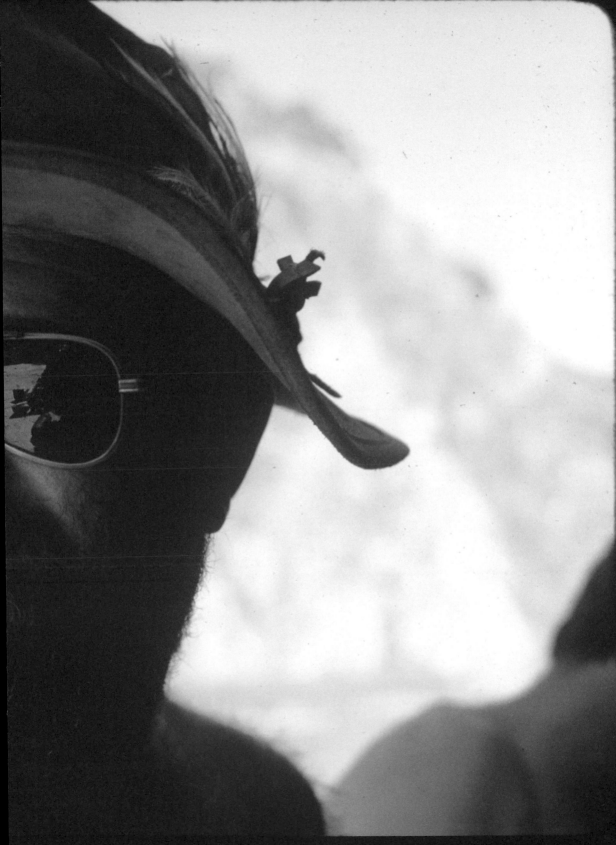

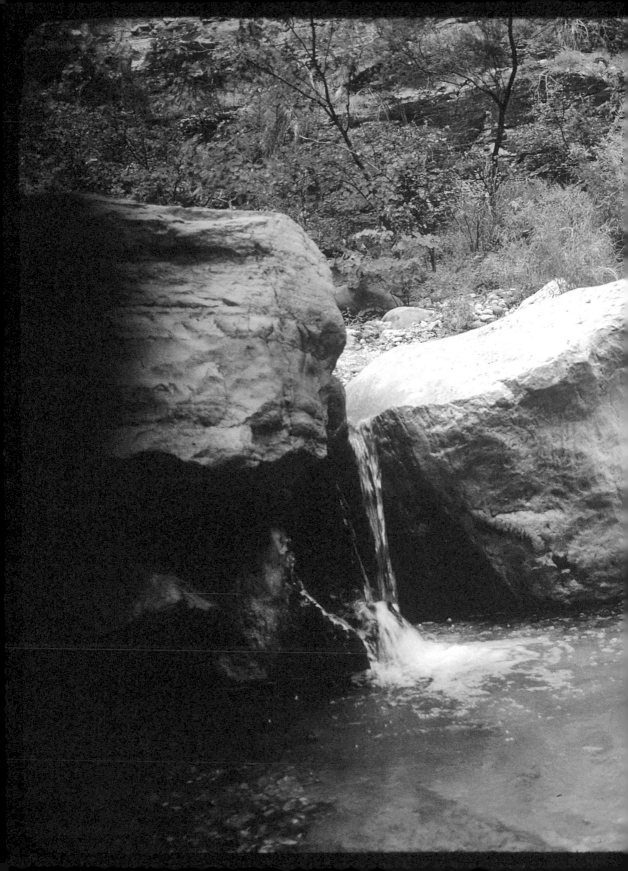

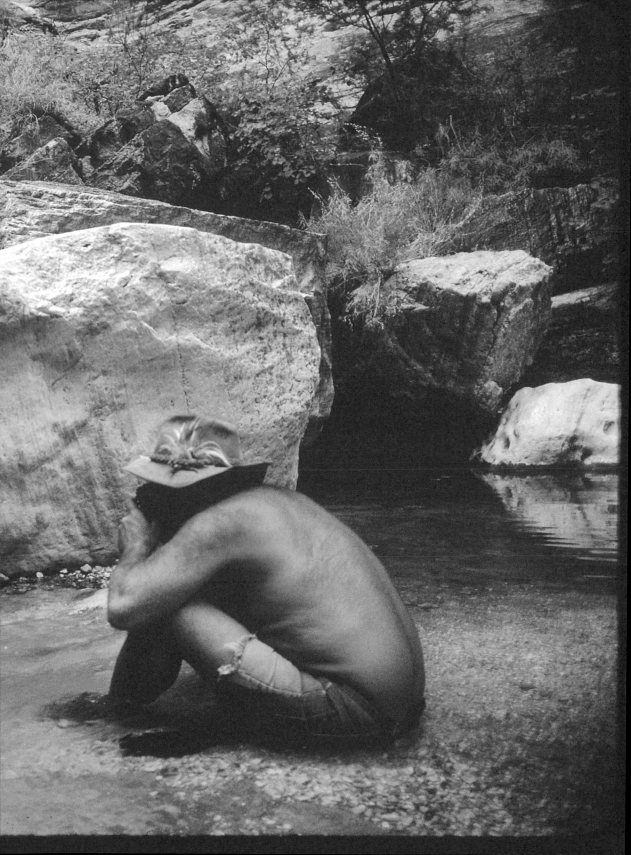

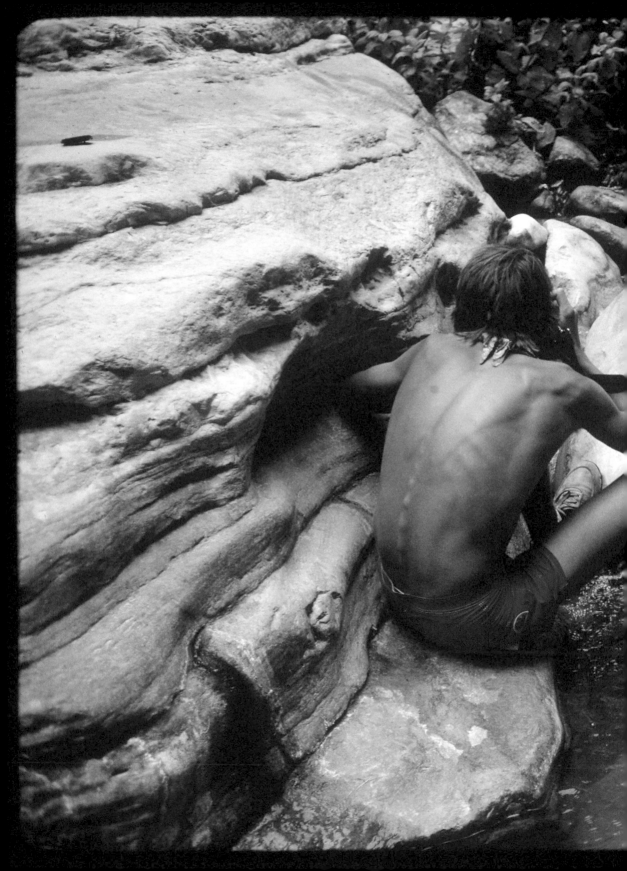

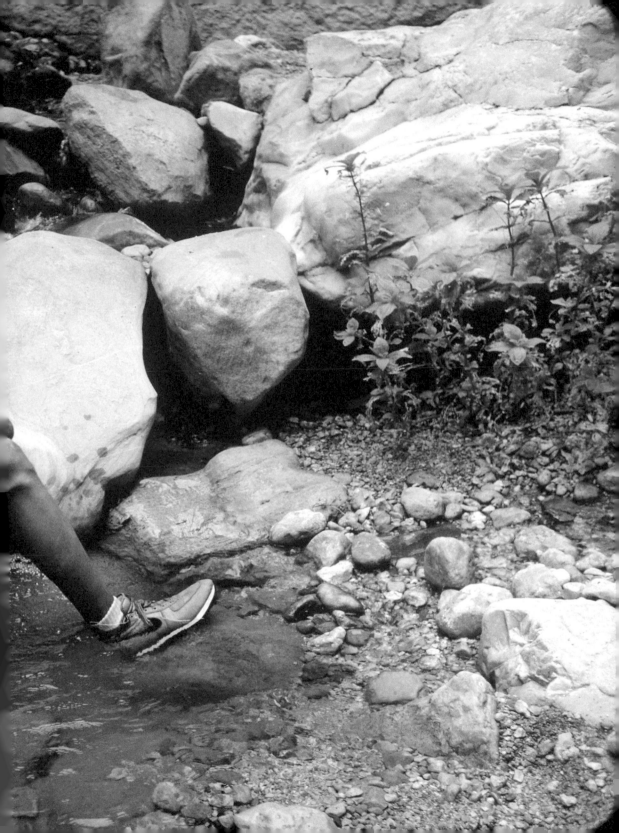

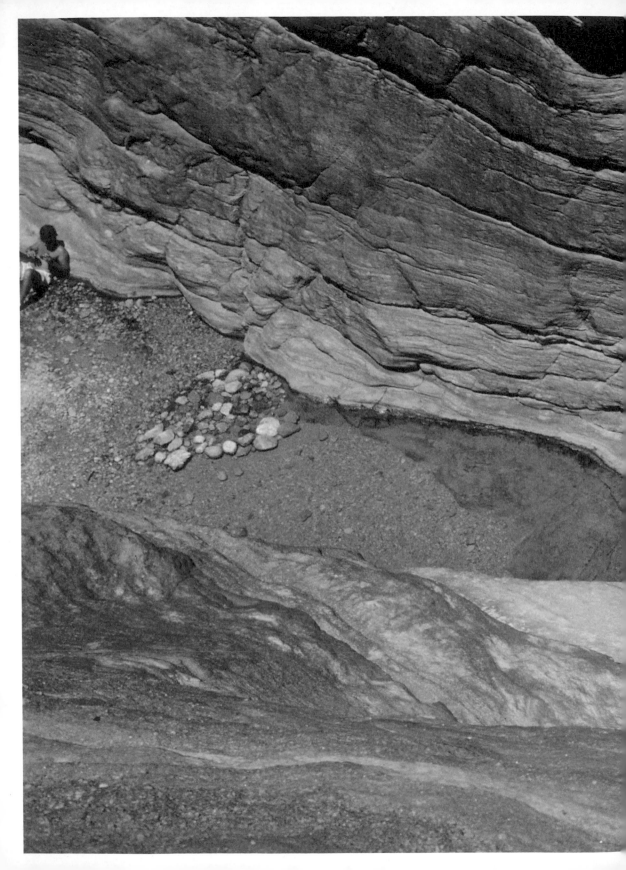

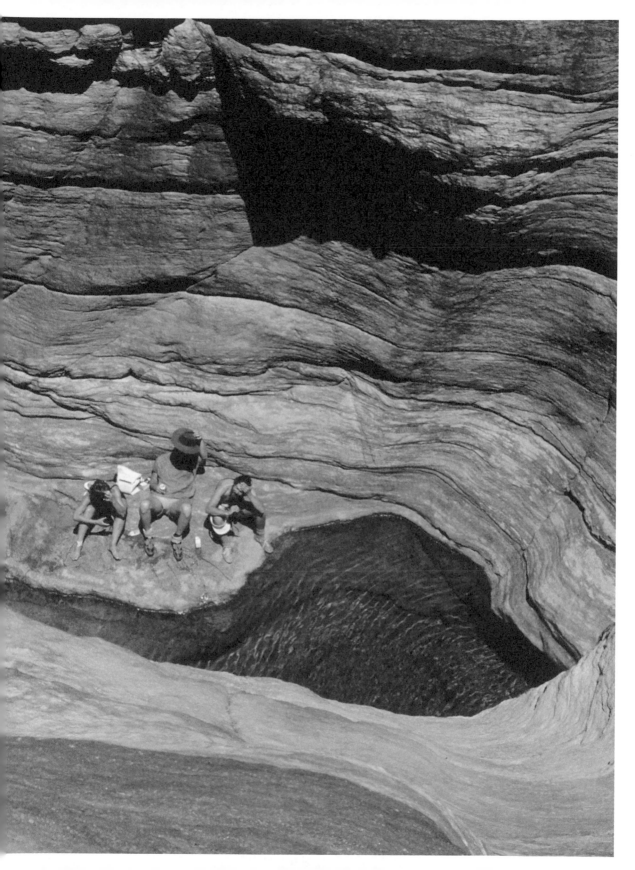

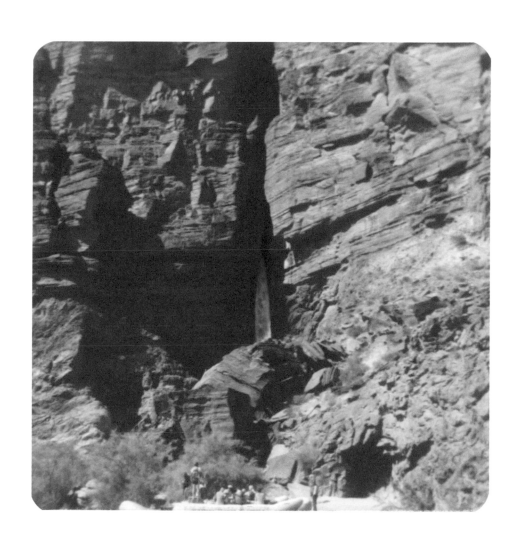

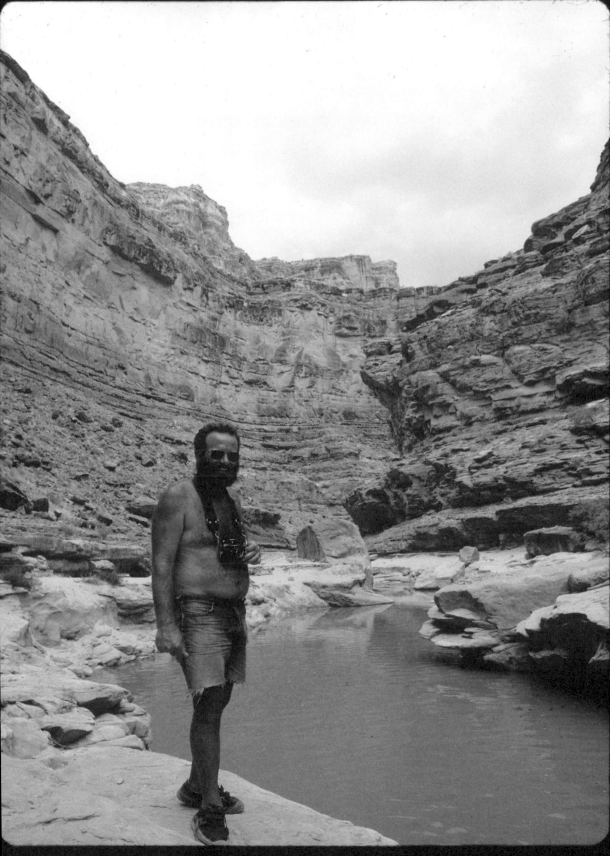

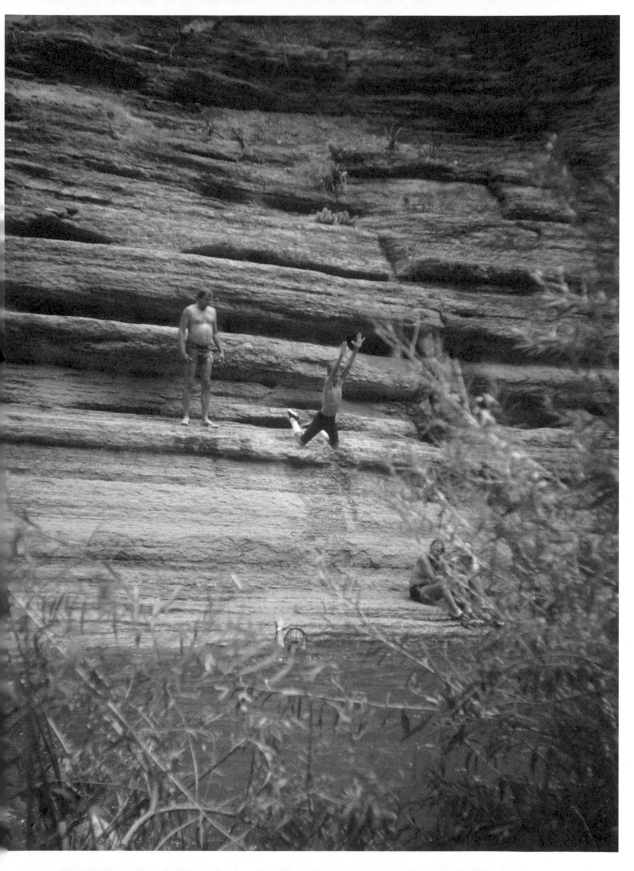

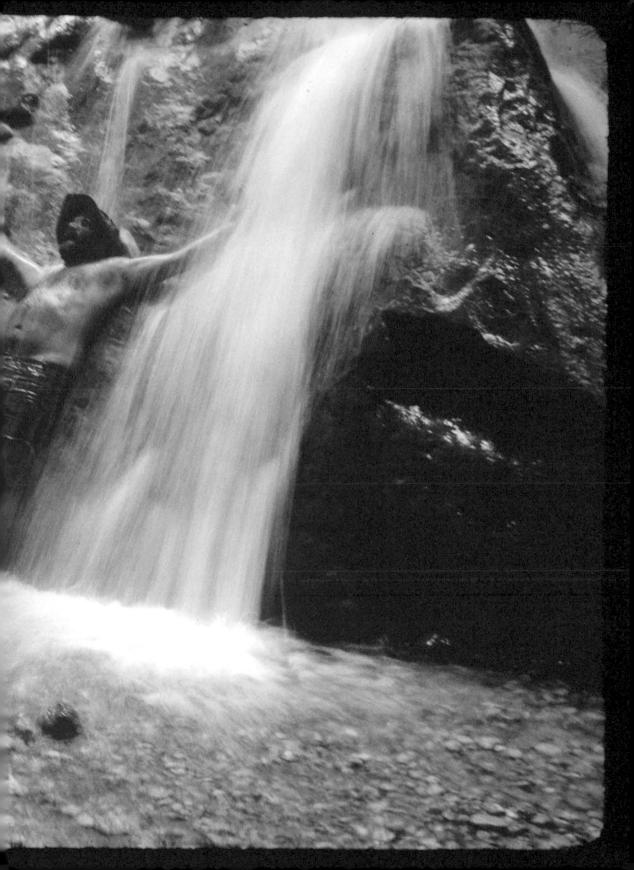

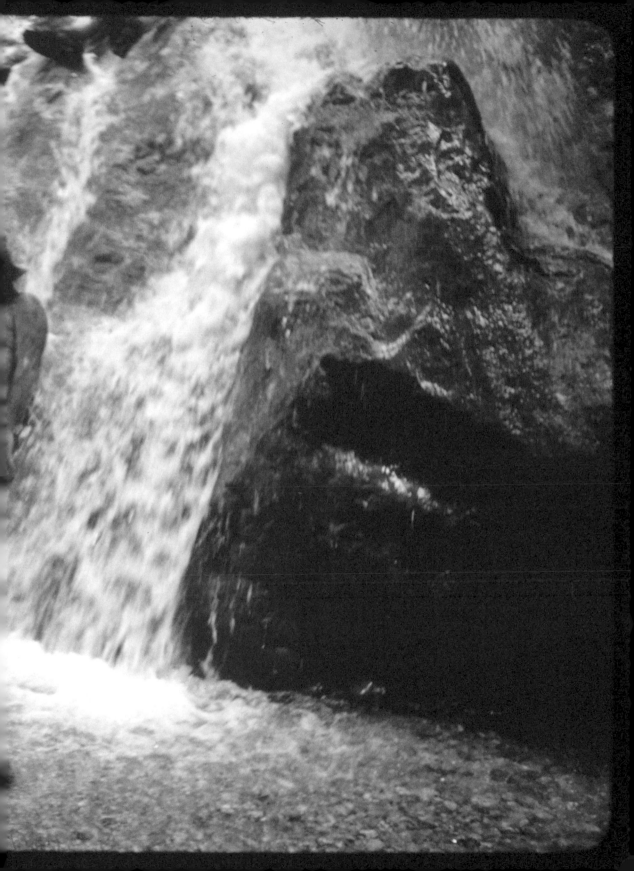

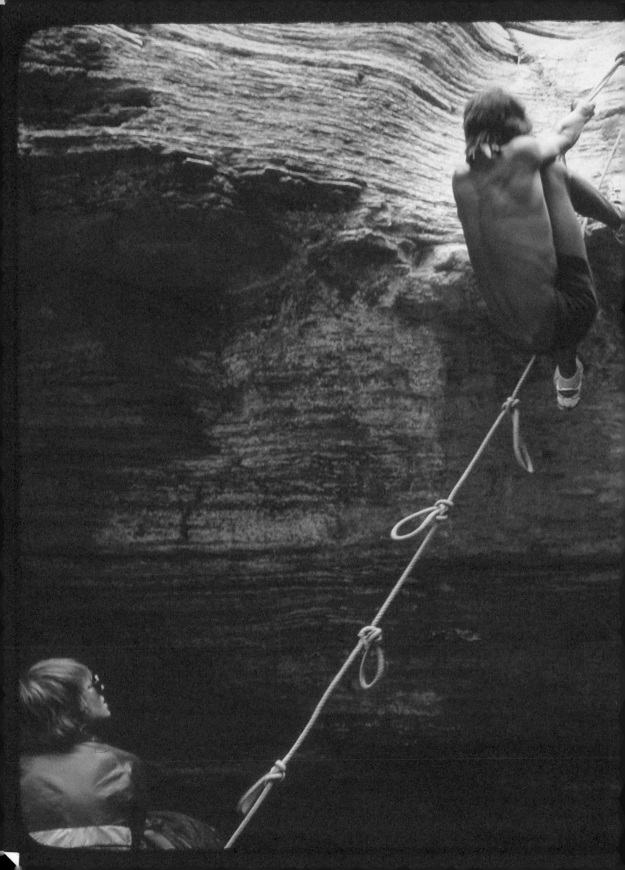

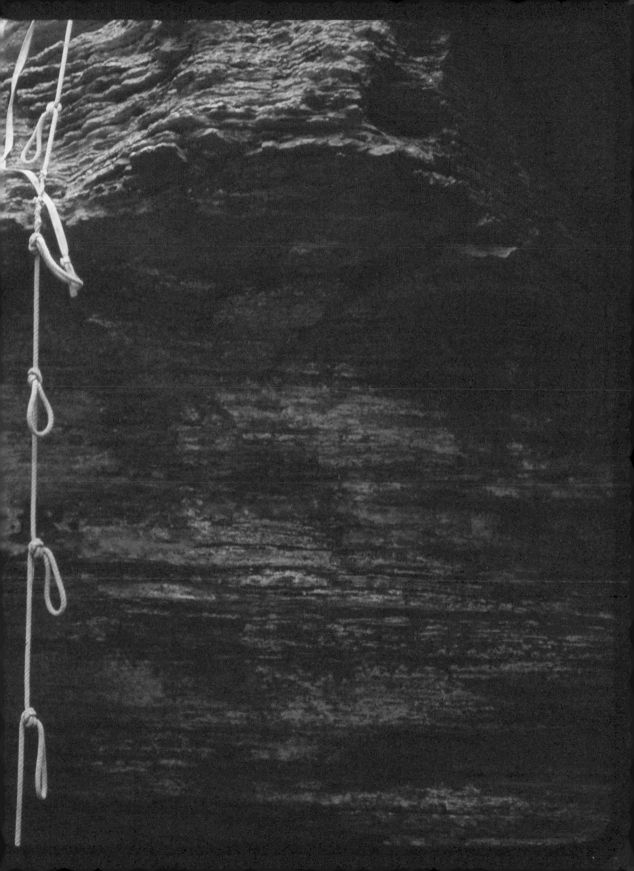

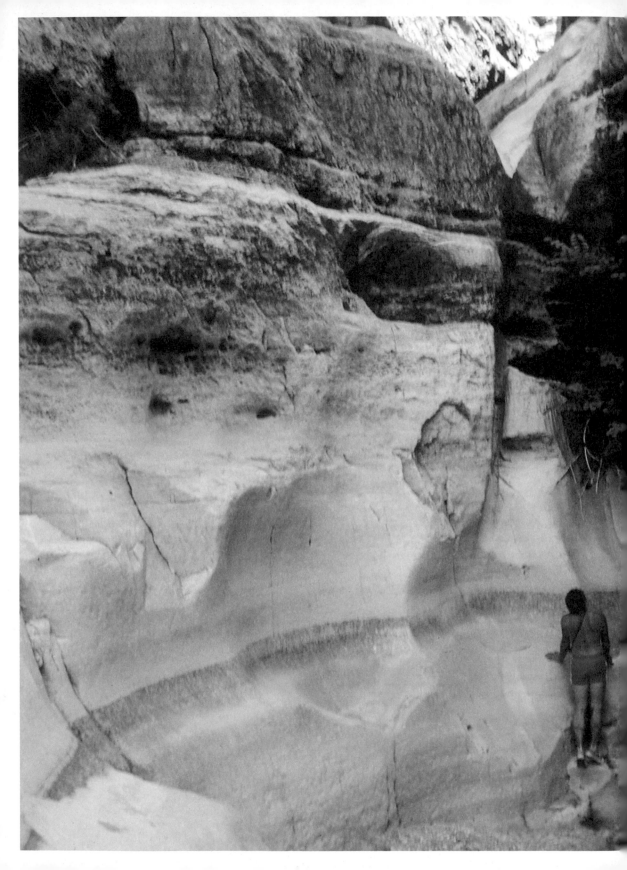

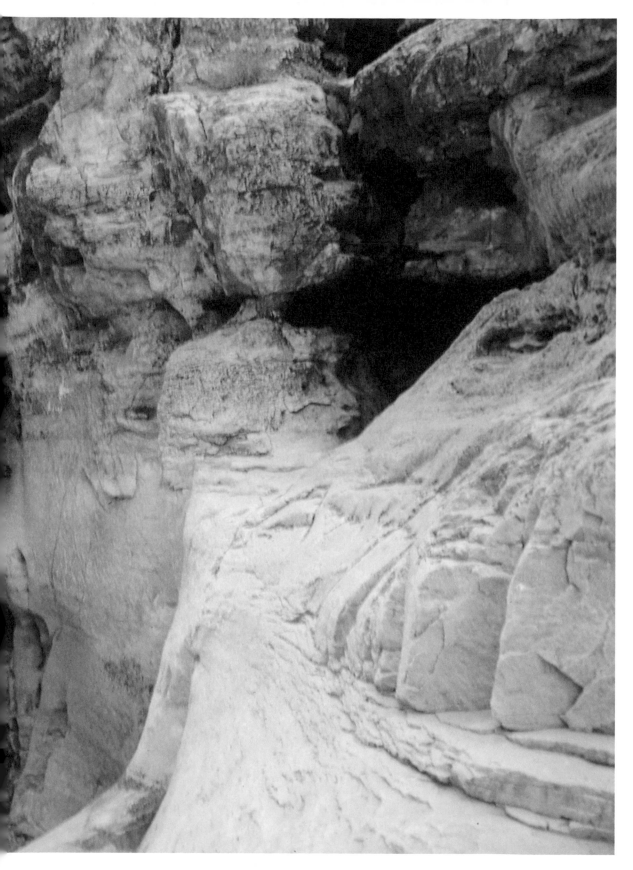

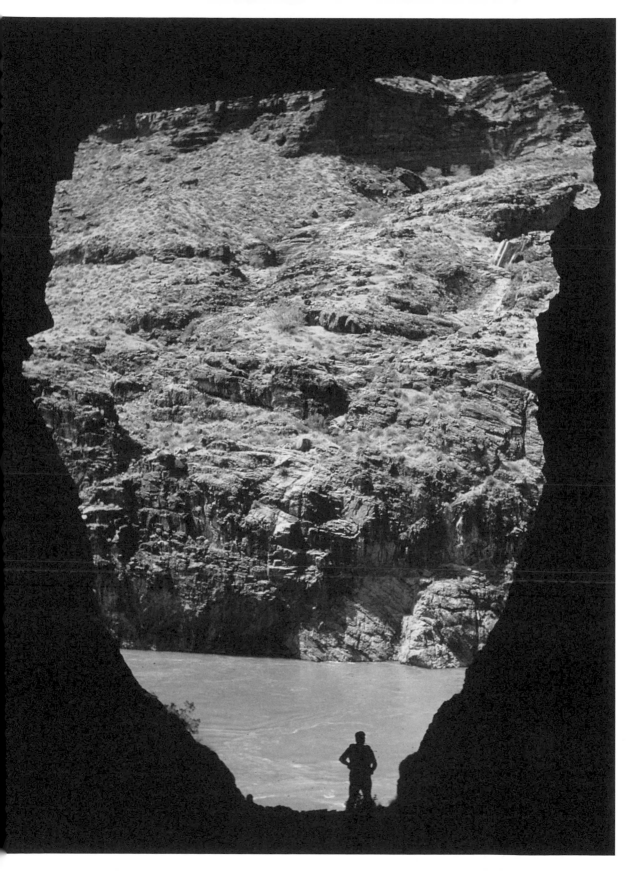

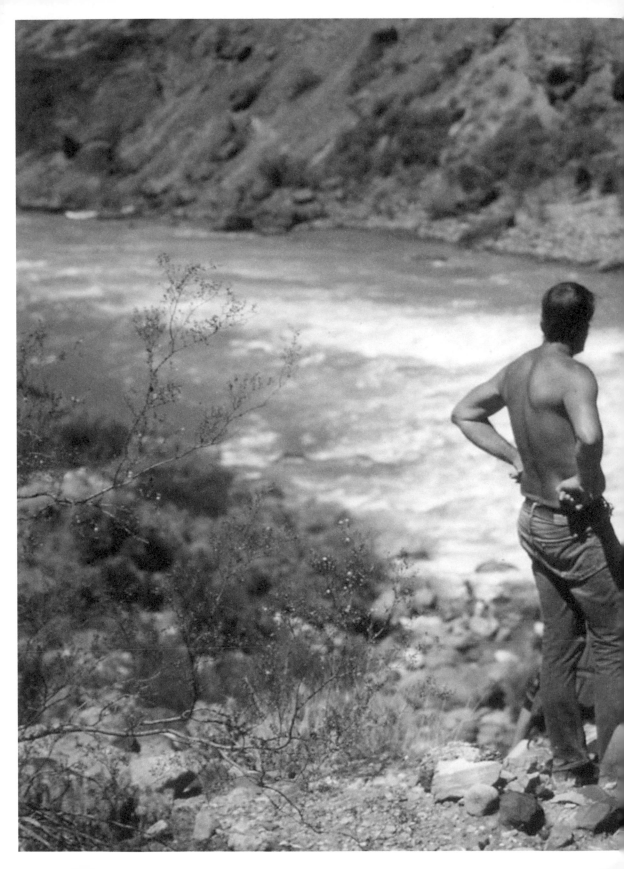

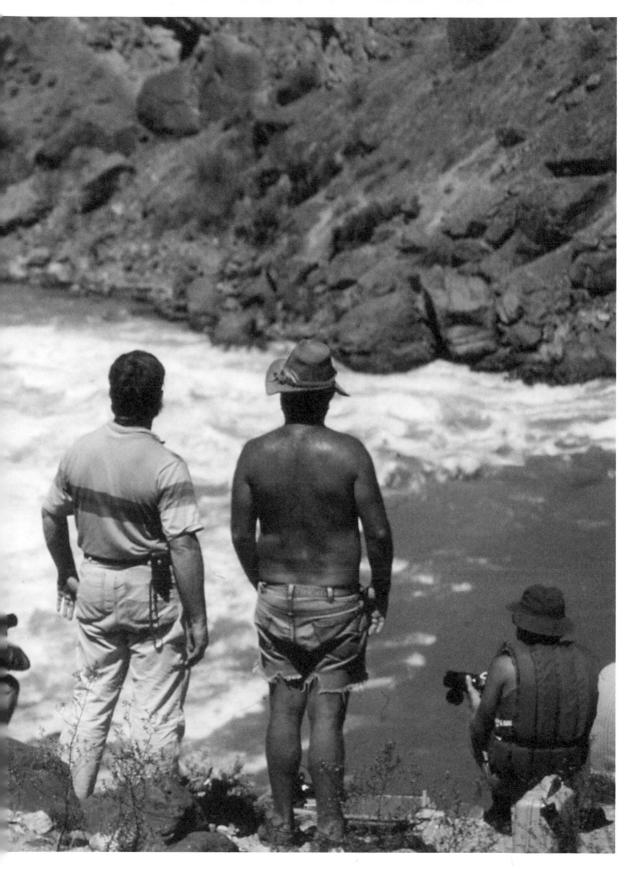

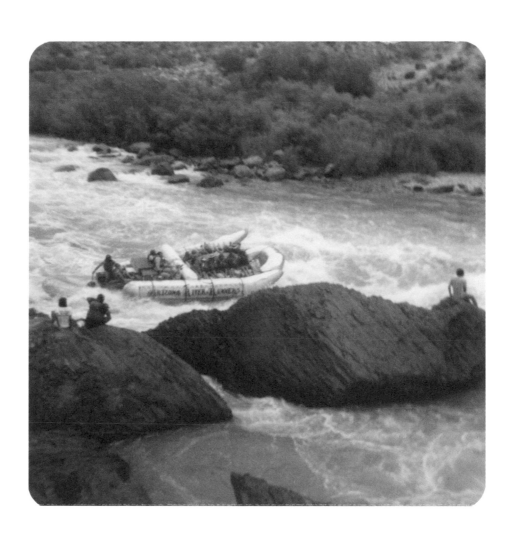

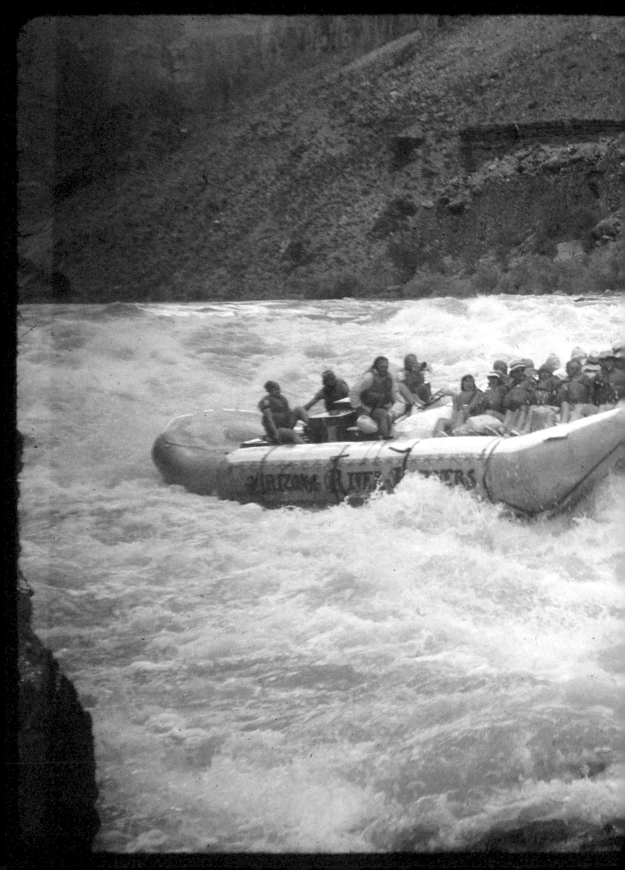

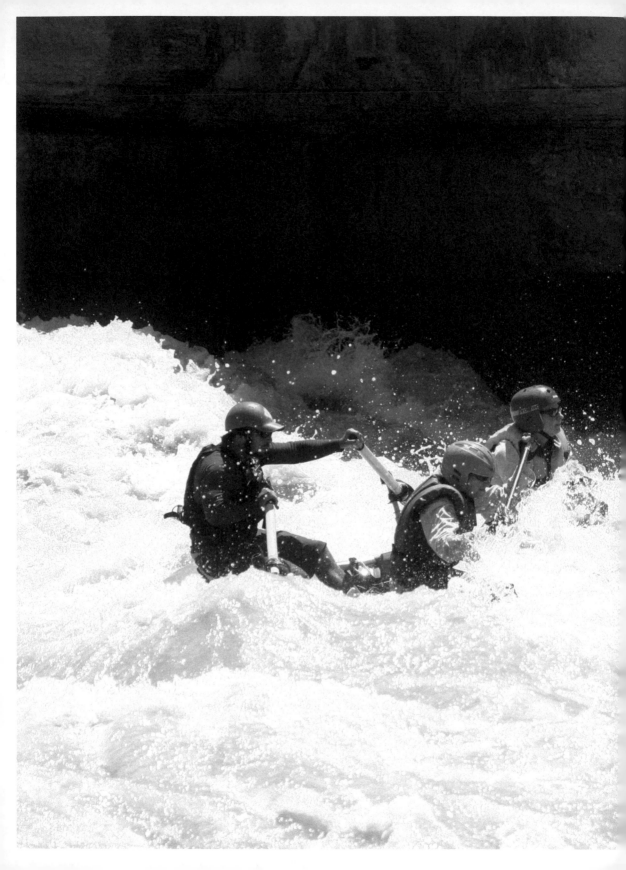

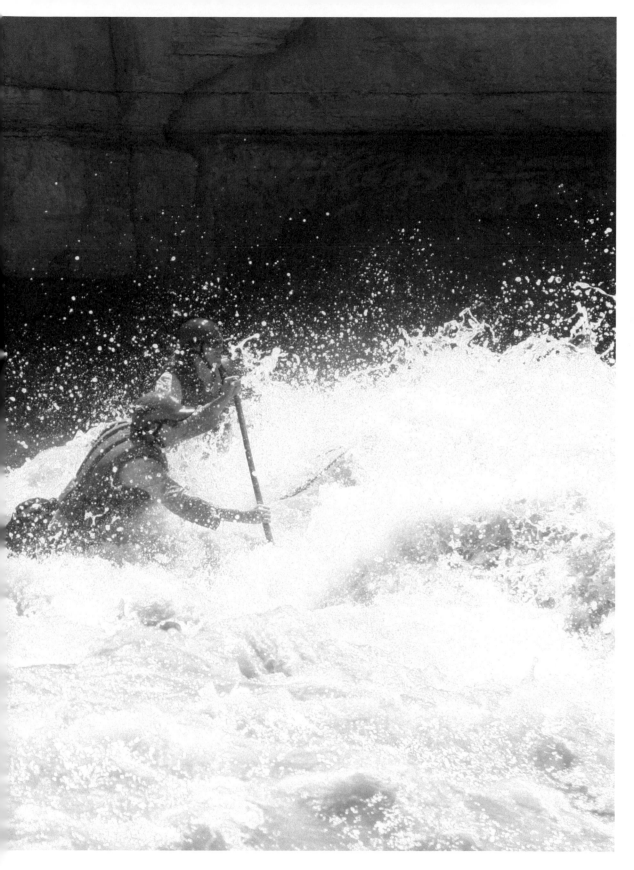

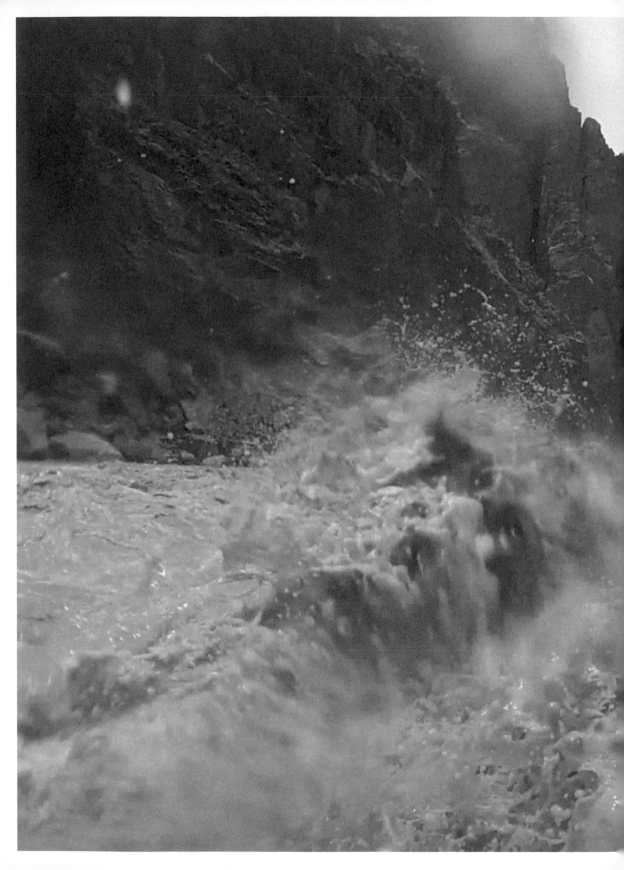

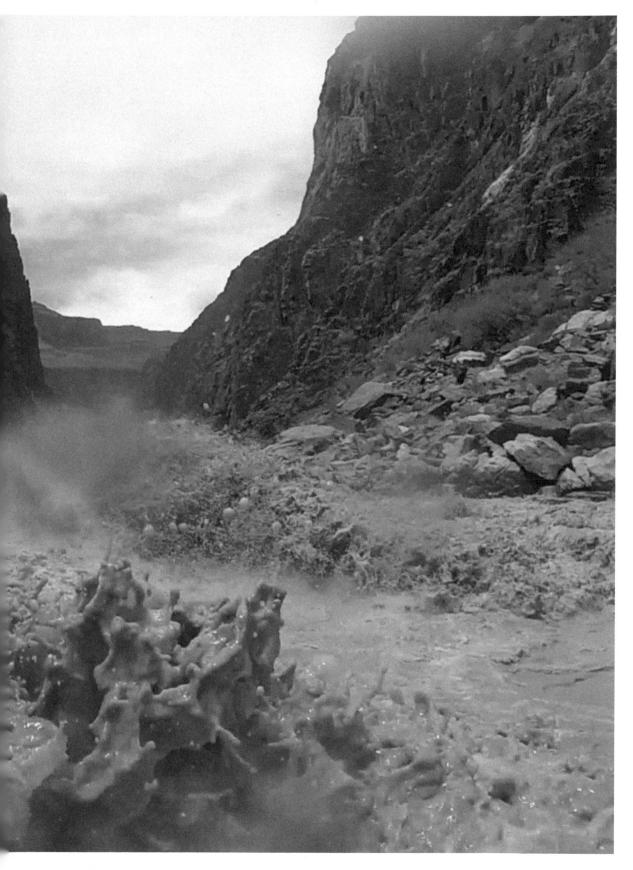

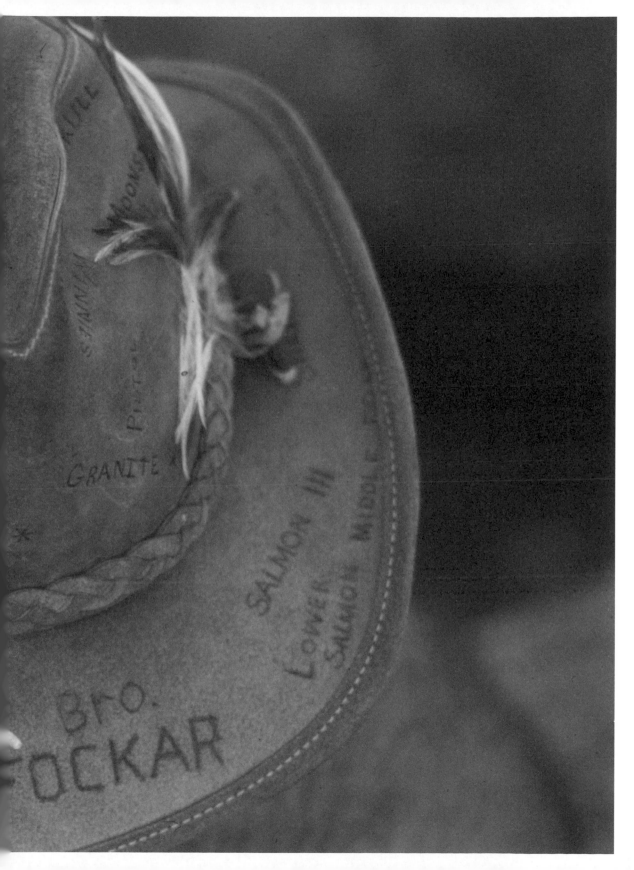

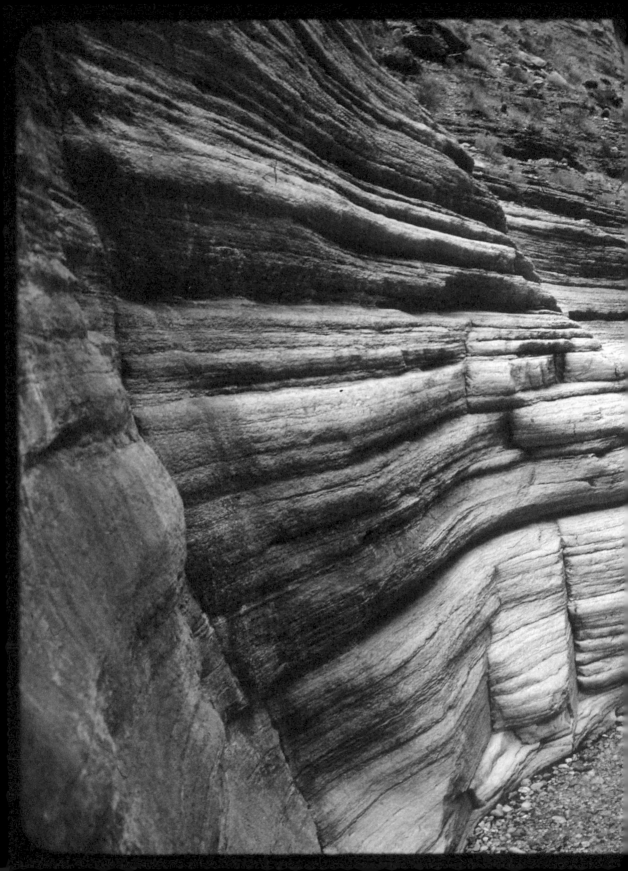

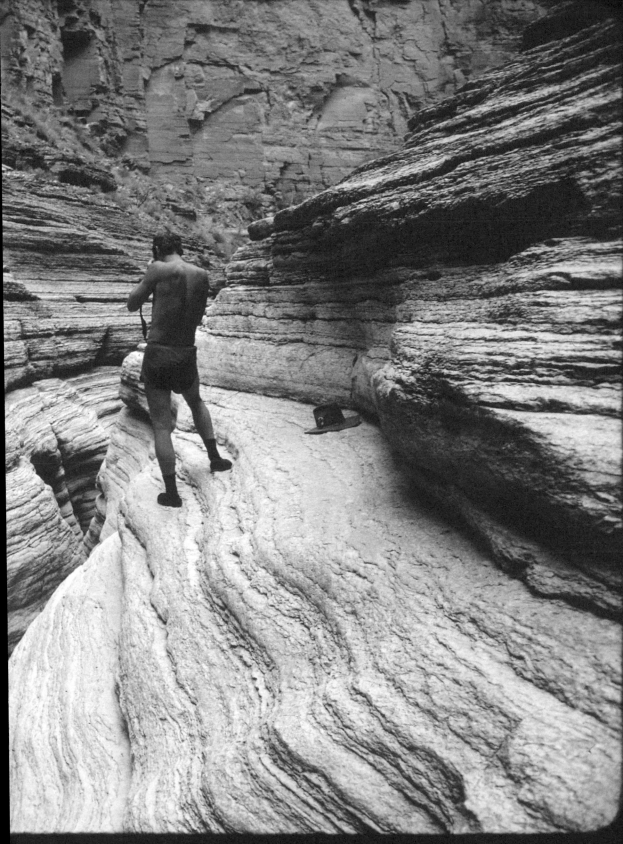

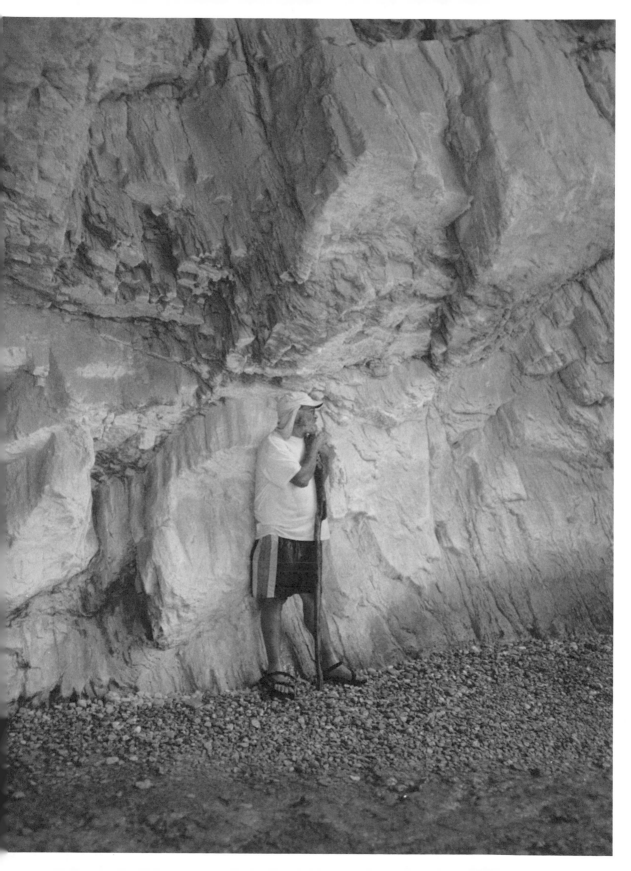

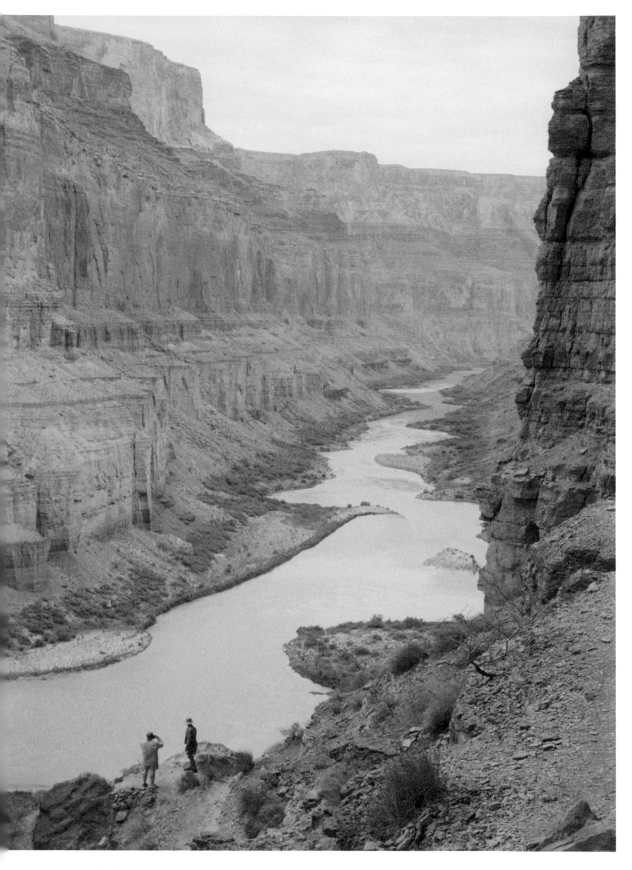

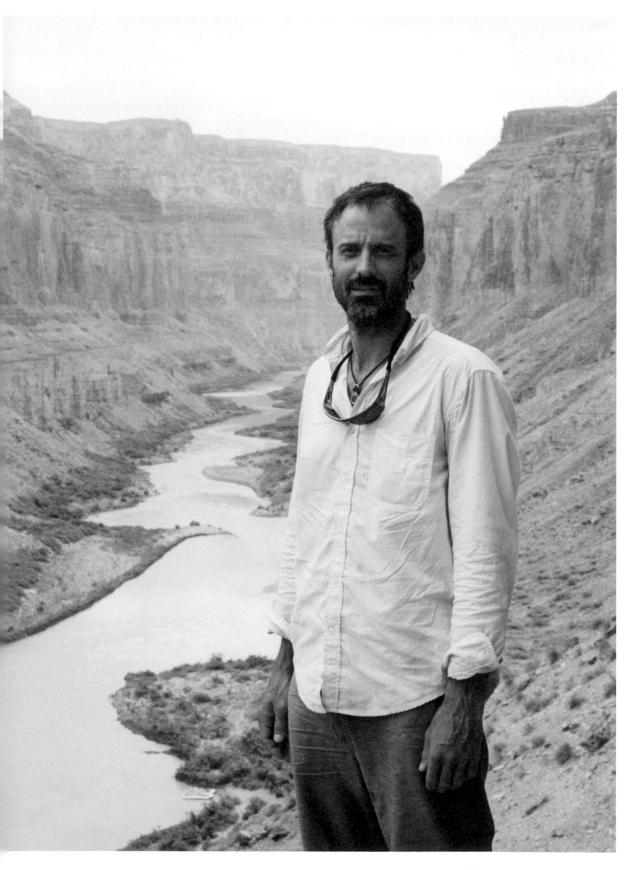

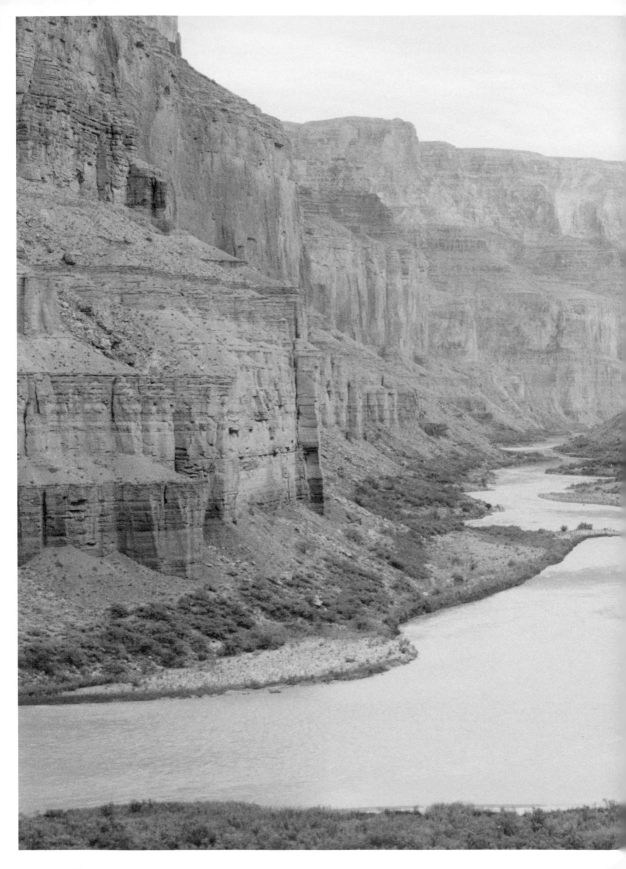

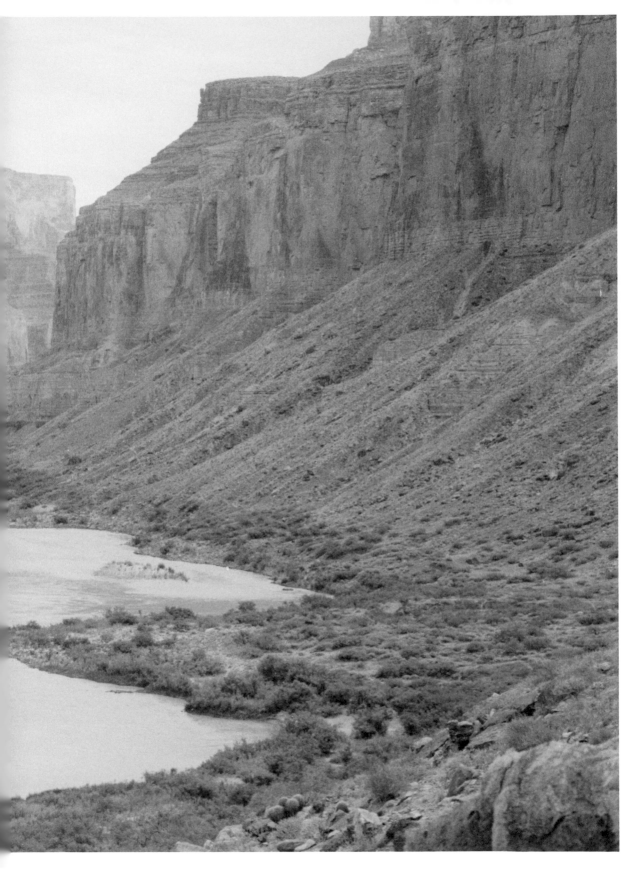

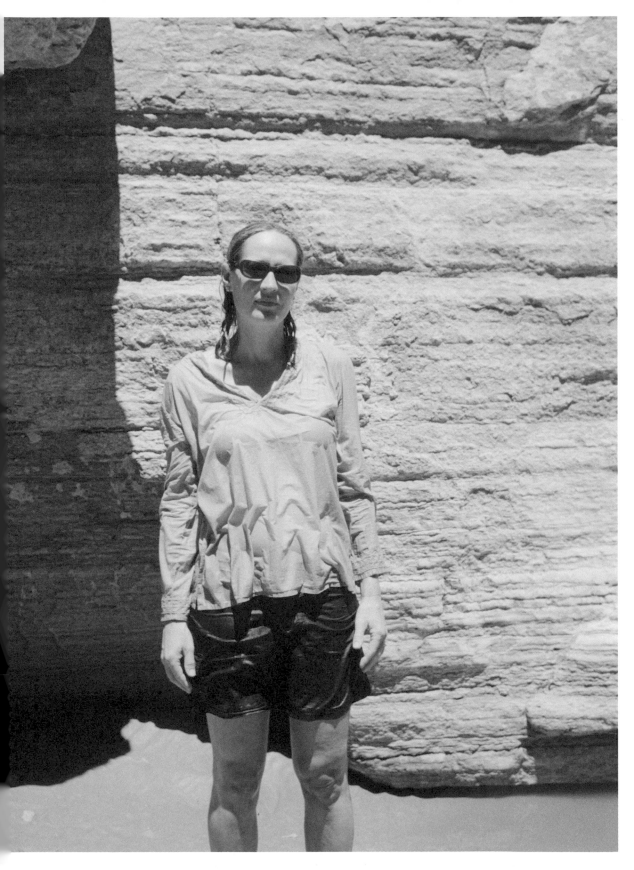

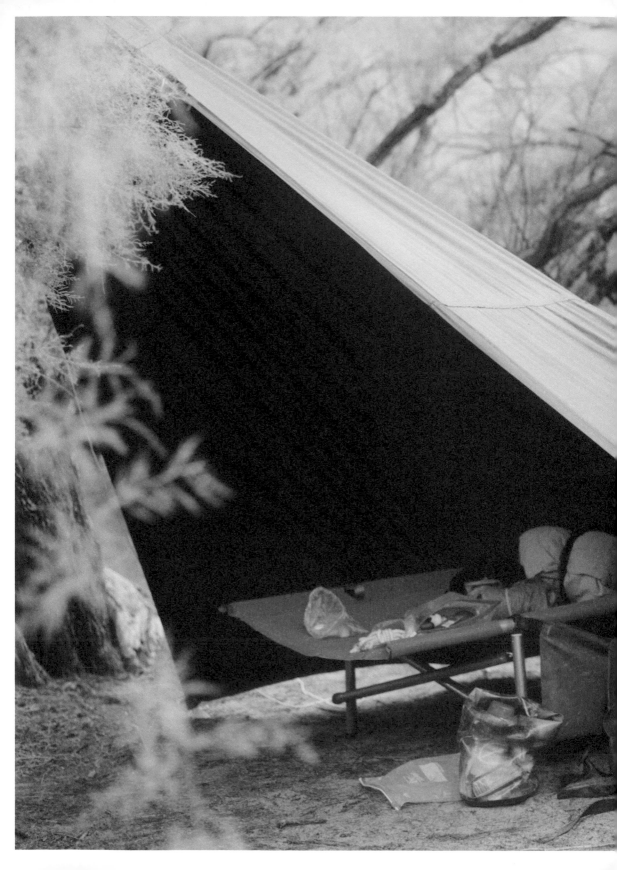

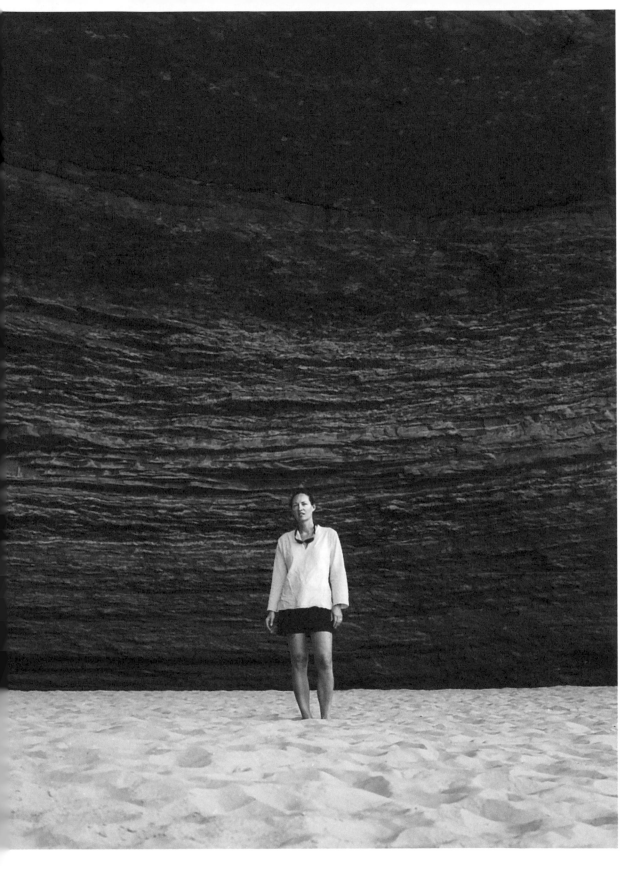

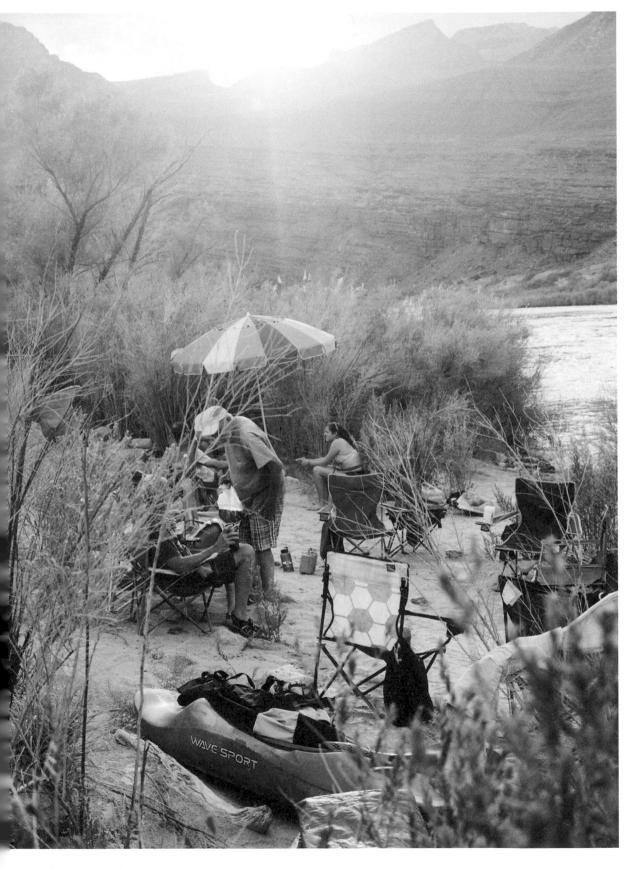

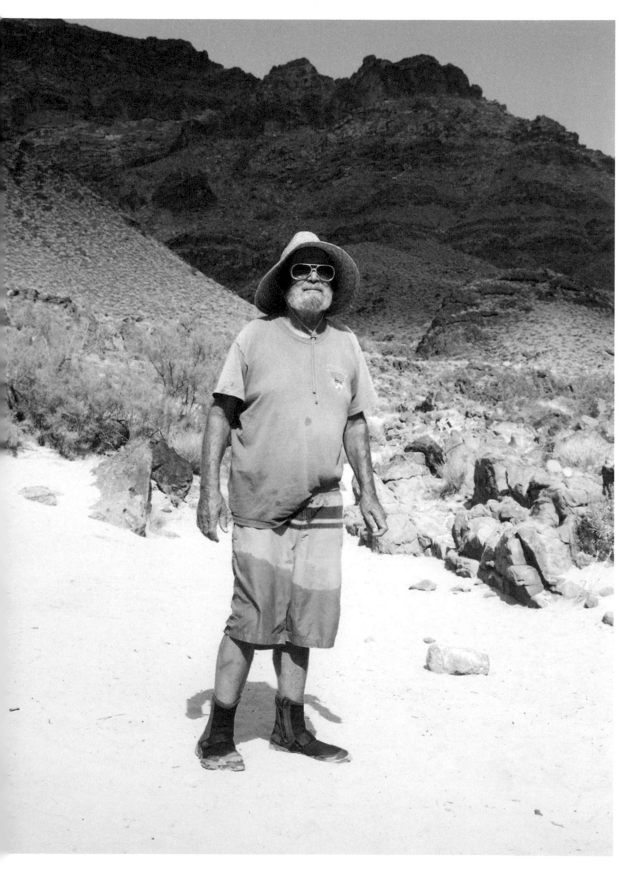

From my notes. Winter 1984-85

As I read over my Grand Canyon notes, I remember so many
things I failed to mention. That is why they are called memories,
and are a big part of running the river.

I see where every time I try to put my feelings into words, I can't.
That is probably for two reasons. One is that I'm not a writer, but
more so is I have nothing to compare it to. It's something I really
wanted. Maybe, to another river runner who has done it before,
the Grand might not mean so much. To me it was not a goal, but
more of a dream come true.

As I read my notes, I feel maybe, just maybe, I exaggerated a bit,
but I'm leaving it like it was written at the time, because it is part
of the dream.

I hope in my lifetime I get to ride the back of the very creator of
the Grand Canyon many times. One thing I'm sure of is that I
will never get to do it for the first time again. That feeling of pull-
ing on your own oars, in a boat of your own design and creation,
the feeling of doing it your way for the first time in the Grand
Canyon, I still can't put into words.

Brent Phelps

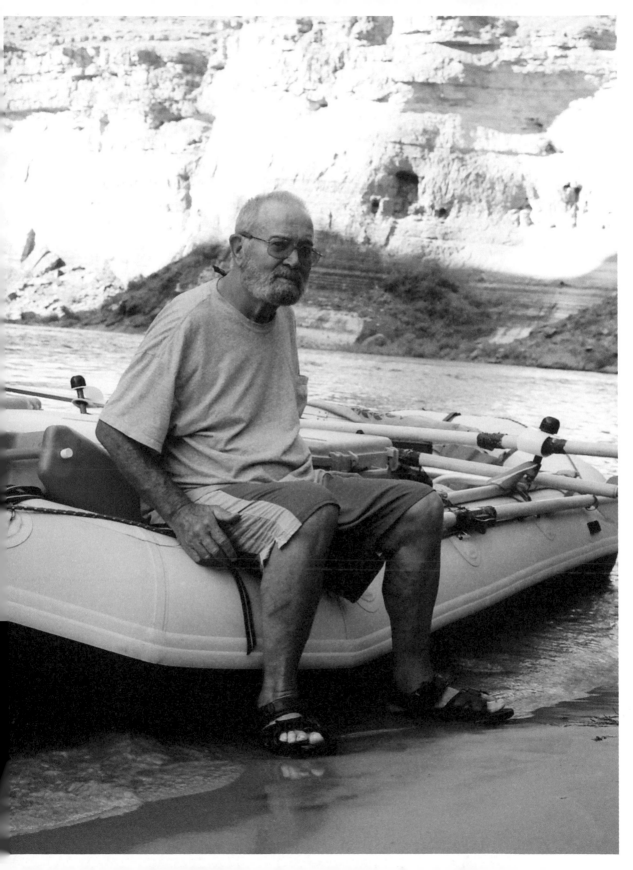

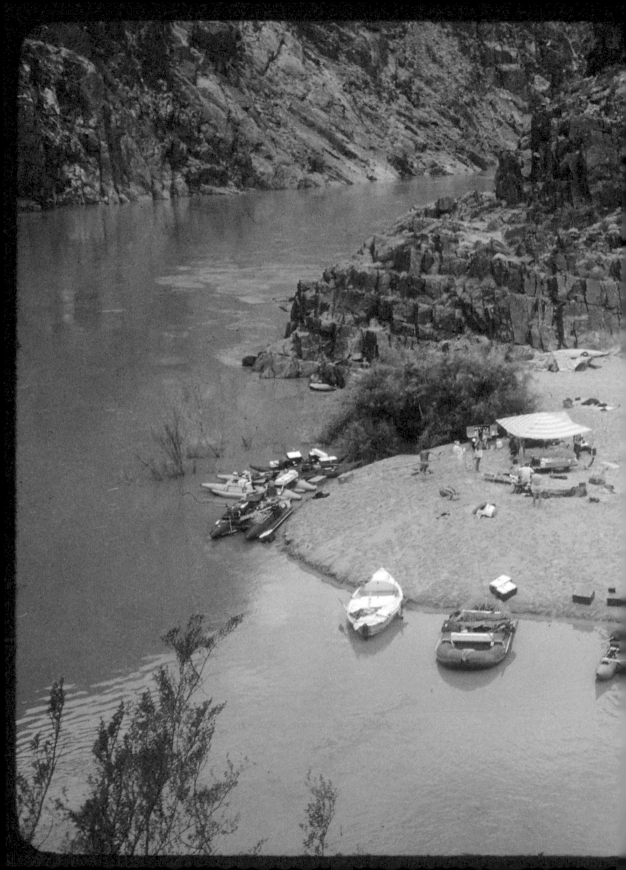

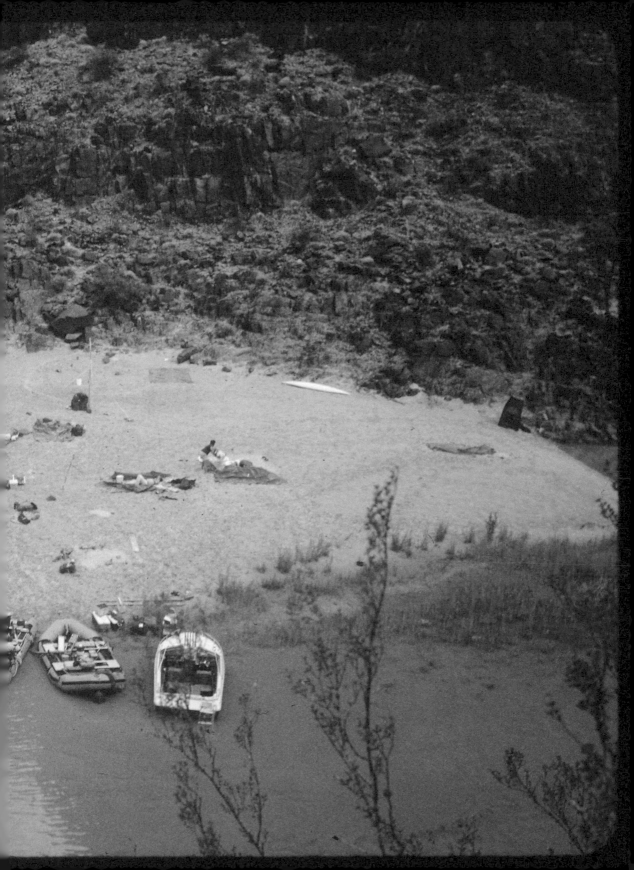

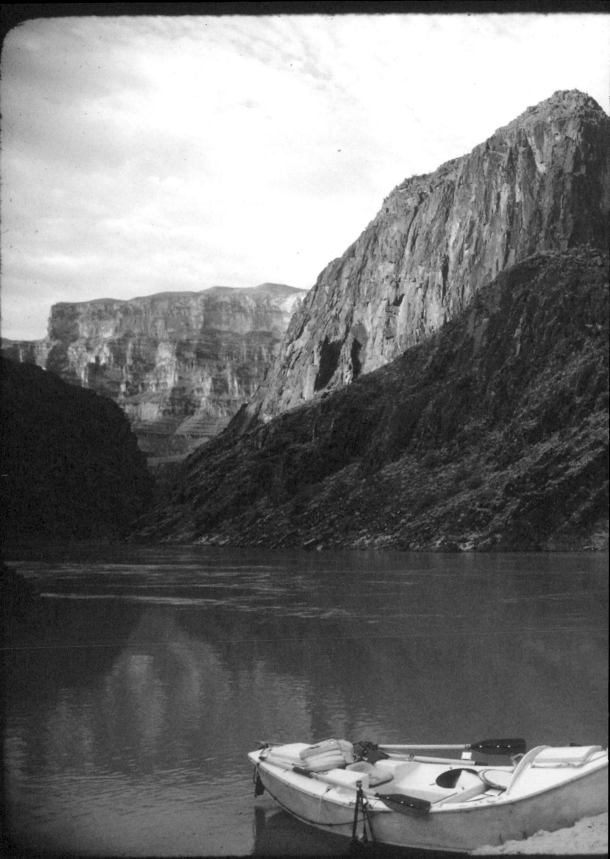

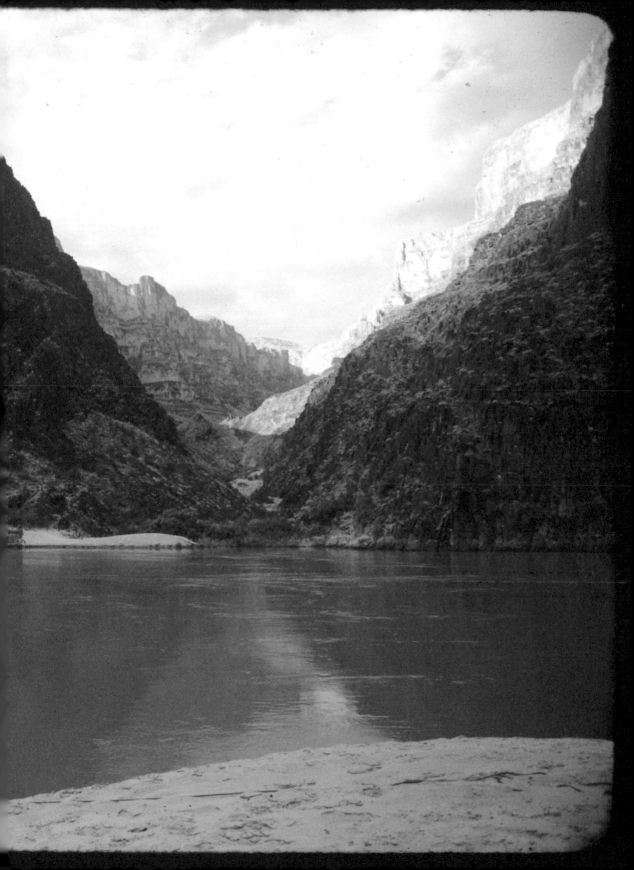

© 2015 Andrew Phelps and Fotohof *edition*.
All images from the archives of Andrew and Brent Phelps.

There are a handful of friends who have consistently contributed photos
to our archive. I am grateful for the use of their images over the years,
and I am sure several have found their way into this selection:
Frank Lupton, George Hefner, Ben Glahn, my wife Nathalie.
Map design Kerstin Hölzl

www.andrew-phelps.com
www.pocproject.com

FOTOHOF *edition*
Inge Morath Platz 1-3
5020 Salzburg
www.fotohof.at

ISBN 978-3-902993-12-0